SACRAMENTO
BEER

SACRAMENTO
BEER

A Craft History

JUSTIN CHECHOURKA

Foreword by Daniel Moffatt, Fountainhead Brewing Company

AMERICAN PALATE

Published by American Palate
A Division of The History Press
Charleston, SC
www.historypress.com

Cover image provided by Kelly Huston.

First published 2018

Manufactured in the United States

ISBN 9781467138475

Library of Congress Control Number: 2017963916

Notice: The information in this book is true and complete to the best of our knowledge. It is offered without guarantee on the part of the author or The History Press. The author and The History Press disclaim all liability in connection with the use of this book.

To my wife, for not only having the patience to let me do this but for encouraging me along the way.

CONTENTS

CONTENTS

FOREWORD

The History Press reached out to the Sacramento Area Brewers Guild in search of a local author who could write a book on breweries and beer history in Sacramento. The city's exploding beer scene was still very new and changing every day. The same could be said for the guild, as most of us had only recently become involved. Beer in Sacramento was growing at a crazy, exciting pace, and we all wanted to help spread the word in whatever way we could.

We all came from different backgrounds and experience levels, which would prove to be valuable during this process, but finding an author and putting together a book was not something you could call us experts on. Then I met Justin. He reached out to me with an interest in writing an article about our brewery, which had been open less than a year at that point, and he wanted to hear our story. I read a similar article he had written about another brewery and felt he was passionate about the subject and told the story behind the scenes very well.

We got through the standard questions, and the conversation eventually turned to Justin's goals and what he's passionate about. We talked about the idea of a book on Sacramento beer for a few days and eventually connected him with The History Press for the project. The next few months were spent meeting with the people who make Sacramento beer such a great industry, from individual breweries to the Sacramento guild and the California Craft Brewers Association.

His wealth of knowledge and experience in Sacramento gave Justin tons of information about the history and evolution of beer in our area, and while every one of us is always short on free time, it was important for us to be part of this project.

Our city should be recognized for how far it's come in such a short time and by the quality of beer that is being produced, as well as for the huge number of craft beer drinkers and their passion and knowledge of the products and for the community that has been created and is growing every day.

As I played my small part in this project, I have experienced the collaborative nature of Sacramento beer and how our passion for it connects us. I'm honored to be part of this industry in this city. This is easily the most exciting time for beer in Sacramento, and by the time this book is printed, there will be more breweries, more taprooms, more great people in the industry and more great people drinking craft beer made in their neighborhood.

Cheers!

Daniel Moffatt
Owner/Brewer
Fountainhead Brewing Company
Sacramento Area Brewers Guild

ACKNOWLEDGEMENTS

Sacramento's beer scene is booming in a way that hasn't been seen in this area since the gold rush. From 2011 to now, we've seen the number of craft brewers in this region explode from about six to around sixty. It's a transformation that's been hard to ignore. So about two years ago, I started to ask the question, "Who are the people behind these breweries?" I started seeking out these modern pioneers of craft brewing and writing about them.

During one of my meetings with Fountainhead Brewing Company's Daniel Moffatt, I expressed interest in writing about the history of the industry here. Daniel told me he was part of the Sacramento Area Brewers Guild and that the group had been approached to find someone to write a book about Sacramento beer, and here we are.

I spent several months working on this book, conducting dozens of interviews with brewers, brewery owners and business owners. I want to thank them all for taking the time to talk to an author they've never heard of and for trusting me to tell their story. Their honesty about the business, the challenges they face and the successes they have found was truly appreciated. The craft beer business could be ultracompetitive, but instead it is really a fraternity of beer lovers who help one another out when it's needed, and I'm honored to have been a little piece of it for the time I spent working on this book.

Truth be told, I initially wanted to write the history of brewing in this area, but it turns out that's been written and written well by a man named

Ed Carroll. If you are a big-time beer history buff, his *Sacramento's Breweries* is a must-read.

"It was a project I started in the mid-'90s on my own. I collect a lot of beer memorabilia; it's always been a big interest of mine. I did it for a while in the mid-'90s, but I didn't know how to do research that well, so I did it sporadically," Carroll explains. "Then in the mid-2000s, I went back to graduate school for a degree in public history, and that's where we did a lot of research, and I realized that was the perfect time to turn my project into my thesis."

I'm not ashamed to admit that I leaned heavily on Carroll's work (with his permission) to help bolster my own research into this region's history of brewing.

James Scott in the Sacramento Room at the Sacramento County Library was also an incredibly valuable resource for this book. I want to be clear that this book is in no way a complete retelling of the history of brewing in this area. Hopefully, I'm giving you enough of a history lesson that you'll be ready when beer history is the topic at your favorite brewery's next trivia night.

Thanks to Dr. Charlie Bamforth, who was actually my very first interview for this book. I can honestly say I had no idea the reach and impact UC Davis's brewing science program has had through the decades. With Charlie's impending retirement, the university will be blessed if it can find someone with half as much passion for the program and for beer in general.

Finally, thanks to all the beer lovers out there who have been incredibly supportive of the book. Hopefully, it delivers everything you hoped it would.

INTRODUCTION

For my money, Sacramento might just be one of the truly underappreciated cities in this country—great weather, centrally located to both the mountains and the ocean, not too expensive and, as of the last ten years or so, home to some really great beer.

The region is now home to about sixty breweries, which is pretty impressive considering just a decade ago that number was fewer than ten. While the rapid growth might surprise you, it turns out that Sacramento was late to the craft beer party.

"The original excitement was centered around the Bay Area and oddly enough up the North Coast in the '80s and early '90s. The San Francisco Bay Area and Sonoma and up the North Coast was kind of the center of craft beer in the state," says California Craft Brewers Association executive director Tom McCormick. "I think there's been a dramatic cultural shift in Sacramento."

And it's true. As the landscape of beer in Sacramento has changed, beer has changed the landscape of the region. The breweries have changed the way we socialize, truly becoming that "third place." A brewery might host a band one night and yoga the next morning. But what you'll consistently find are kids, dogs and friendly faces.

"One of the most family-friendly places is our breweries a lot of the times now," says Lauren Zehnder at Mraz Brewing Company. "We can meet our friends and we can bring our kids, and we can all hang out and have a good time."

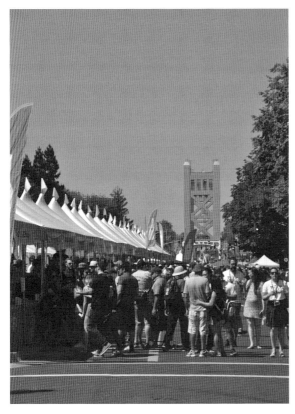

Left: The state capitol on one side, Sacramento's Tower Bridge on the other of the California Craft Beer Summit Beer Festival. *Melissa Chechourka Collection*.

Below: Inside New Helvetia Brewing Company in Sacramento, where on the far wall you can see the tribute to Buffalo Brewing Company. *New Helvetia Brewing Company*.

"We've had people do bridal showers, and strangely enough, we've had a few baby showers in here and other events like that," adds YOLO Brewing Company CEO Rob McGormley.

It's clear these breweries have become more than just a place to have a pint. In less than a decade, they have become interwoven into the fabric of the community, with charitable donations and fundraisers as part of their business plans.

"I want Track 7 outside of the beer industry to be known as a business that really tries to give back to the community and is a part of the community. And people can have fundraisers here," says owner and co-founder Geoff Scott.

"We're such a welcoming place for such a vast group of people, and we have such a huge venue, that we're the place the baseball team comes to meet after the game or the PTA comes or the local city community is organizing a fundraising event, and they need some place to meet to do their planning meetings," adds Crooked Lane's head brewer, Teresa Psuty.

Making it even more amazing, outside of the occasional downtown or central location, most of these breweries are located in out-of-the-way industrial parks. It hasn't mattered. The breweries have transformed unexplored and sometimes forgotten areas into regional hot spots.

"It's emerged as a destination for the community, for the city, that I think a lot of folks are proud of," says West Sacramento mayor Christopher Cabaldon of the city's industrial port area. It's now home to Bike Dog, YOLO and Jackrabbit Brewing companies. "It's also just a great place to hang out that's comfortable and relaxed that vibes off the industrial and urban heritage of the city."

"On the weekends, most of our clientele come from out of town," says Karen Powell, owner of Auburn-based Moonraker Brewing Company. Auburn has in the past been viewed as a pit stop while traveling to Tahoe. Not anymore—not with four popular breweries. "Our beer has such a following they come here to try it. A lot of people from the Bay Area and beyond. We have people from LA."

From the rise of craft beer comes the rise of the beer-related industry. It consists of eager entrepreneurs finding their own niche in the beer world, without actually making beer.

"We kind of wanted to get into the industry and experience what was going on in the scene," says Scott Scoville, one of the founders of Beers in Sac, a company that specializes in beer event marketing and planning.

Rancho Cordova's Fort Rock Brewing Company is one of the few new breweries to open in something other than an industrial area. *Author's collection.*

All of this is why craft beer has become *the* story in this region. Former *Sacramento Bee* reporter Blair Robertson's assignment even changed to include writing about the latest comings and goings in craft beer. "I wanted to tell the story of the evolving industry in Sacramento and how people were reacting to it," he says. "I had trouble keeping up with everything that was going on, which was kind of exciting in a way—not even having time to go to all the new breweries."

The malaise of the '90s is now being replaced by the high standards of the area's increasingly educated drinkers. Inconsistent or poor-quality beer will not be accepted. With increased competition, the breweries have no choice but to meet those high standards.

"Brewing is an art as well as a science, and you need both of those to be successful long term," says Ken Grossman, whose Sierra Nevada Brewing Company is an empire with breweries on both coasts. "You need to be creative on the artistic side and innovative on the beer development side, but you also need to have strong quality control roots. And it takes a lot of hard work to make consistently great beer."

"I think the key to the whole thing is the enthusiasm and knowledge of the local consumer has really, I think you've seen it in the last five years, has gone from zero to really a great level," Robertson adds.

Crooked Lane sign.
Author's collection.

In this book, we'll look at the very first beer boom in this region that just happened to coincide with one of the defining eras in California's history: the gold rush. We'll also examine how this modern liquid gold rush got started, the breweries that played important roles in getting this trend started, how craft beer is helping to shape the community and just how difficult a business it is to be involved in.

Finally, we look at the future of beer in the region—not so much gazing into the crystal ball but more at what's happening now that is already shaping the future of the industry as a whole, including the brewing program at UC Davis, as well as the reemergence of hop growing and how beer and politics are coming together.

What I hope you can take away from all of this is that beer is important. Whether you're a craft beer enthusiast or you prefer Bud, the one thing that is for certain is that beer is bringing people together in this region. So enough introduction; it's time to drop some serious beer knowledge with interviews from dozens of brewers, brewery owners and beer experts throughout the area.

Cheers!

P.S. It wouldn't be right to read this book about beer without beer. That's why throughout this book I'm going to offer some beer pairing suggestions, using some of the area's finest offerings. Hopefully, the chapters will go down as easily as the beer.

PART I

THE PAST

BREWING HISTORY 101

Before we can talk about the history of beer in California, we should probably talk about the history of beer in America. After all, history is all connected.

The only drink older than beer might just be water (that's a joke). There are references to some form of beer dating way back. Pottery jars found in Iran show they were used for holding beer seven thousand years ago. Archaeologists have also found a beer recipe etched on Babylonian tablets that date back to around 4300 BC. So it's fair to say beer has been around for a while.[1]

However, it really hasn't been in the United States that long. Virginia colonists are credited with brewing the first beer in 1587 after they got tired of waiting around for the shipments of ale to arrive from England.[2] This beer was typically brewed for home consumption by the women of the home and was described as a hoppy-flavored dark swill.

The first commercial brewery in the United States was opened in the early 1600s in New Amsterdam (modern-day New York). U.S. brewers received a big boost when George Washington said he would only "buy American."

In 1829, David Yuengling opened his brewery in Pottsville, Pennsylvania. Yuengling remains open today and is the nation's oldest brewery despite only serving the East Coast. In 1840, the first lager beer was produced by John Wagner in Milwaukee.

Around 1848, there was a dramatic shift in the world, notably revolutions that sent Germans fleeing to the United States. They brought with them vast

brewing knowledge. Among those German immigrants were notable names like August Krug, who founded what would become the Schlitz Brewing Company, and George Schneider, who started a brewery in St. Louis that would eventually become Anheuser-Busch.

Assuming you're a Californian, you probably recognize 1848 for another reason: the discovery of gold and the ensuing gold rush.

Beer Pairing: Several local beers pay homage to the region's beer history. New Helvetia has its Buffalo Craft Lager and Ruhstaller Brewing Company has its Gilt Edge Lager, but the one I'm going to recommend here is made from a recipe from Sactown Union that dates back to 1853 and the Union Brewery. Sactown calls it "the Catalyst" because it was partially what inspired owner Quinn Gardner to open the brewery in the first place. Gardner says that aside from the inclusion of millet, this beer follows that original recipe.

LIQUID GOLD RUSH

Beer made in Sacramento is fast becoming known as the best in the market. It is reasonable to suppose that these conditions will continue, and that upon the present foundation will be built up a business which will make Sacramento the "Milwaukee of the West," as a beer-producing center.[3]

As just about any fourth grader in California can tell you, in January 1848, gold was discovered by James W. Marshall at Sutter's Mill. At the time, Marshall was overseeing the construction of a sawmill on the American River. It's fair to say his discovery would drastically change California.

Between 1848 and 1857, some 300,000 people came to California. The gold rush was the largest mass migration in American history.[4] But don't think people were coming to California only for the gold.

"One of the things that rarely gets talked about when it comes to people coming to California, typically Central European people coming to California, a lot of people will say right away it's all about the gold," says Sacramento historian James Scott. "Obviously there's a large amount of truth to that. But we're also seeing revolutions going on in Europe at the time; the 'Revolutions of 1848' is probably the most common term used. So you have moderates that are getting pushed by these red reactionaries in

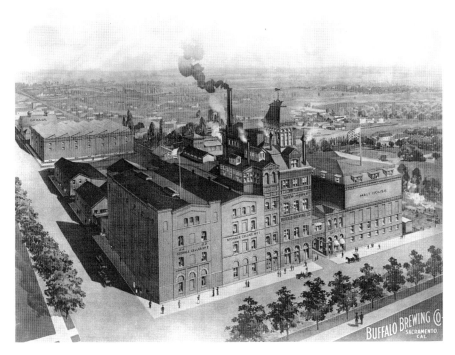

Buffalo Brewing Company. *Center for Sacramento History, Eugene Hepting Collection, 1985/024/3313.*

Germany and parts of Eastern Europe. And so, where do they go? They go to the U.S. They eventually make their way out to California."

Many of the German and Swiss immigrants weren't necessarily coming to California to find gold but to make a living. It was a prime market for a number of businesses, especially beer and entertainment.

"You've got young guys—92 percent of California's population according to the 1850 census was male, and 72 percent was between the ages of twenty and forty. So it's a ready market for brewing," says Scott. The numbers in Sacramento skewed slightly higher, making it a city full of young men who were seeking fortune either in the gold fields or through businesses like brewing.

"In the beginning of the gold rush, that's definitely a supply and demand market," says Sacramento Brewing historian Ed Carroll. "Back then, when you were a German or a Swiss guy and you were a brewer and you were moving to a new place, you set up a brewery because that's what people wanted."

In his thesis, Carroll explains that between 1849 and 1852, a number of small breweries popped up but very few survived more than a year. "There wasn't really a community. You brewed what you needed to, whatever you could make that would pass as beer," he adds.

Part of this may be explained by the fact that these Germans were not necessarily brewers by trade. The 1850 census shows just six people listing themselves as professional brewers.

"Most of the men who brewed in antebellum Sacramento were guys who may have been brewers back in the old country, but a lot of them were accidental brewers," Scott explains. "A perfect example of that is Peter Cadel. It wasn't his life's goal to be a brewer; he just saw the opportunity, he took it and opened the Galena Brewery. Cadel started off as a dairyman. It wasn't going well, so he pivoted to beer."

Started in 1849, Cadel's Galena Brewery is considered Sacramento's first commercial brewery. Carroll describes it as a "neat frame house" located just yards from Sutter's Fort at what is now Twenty-Eighth and M Streets in Sacramento. Cadel's brewery would not stand alone long, as more breweries began to open on the same street. These brewers and businessmen saw an opportunity to make money off the men hoping to strike it rich in the gold fields.

"One of the great examples of someone who came to California, not so much for gold, but because it was Eden, it was land's end, was a guy named Louis Keseberg, who happened to be part of the Donner Party," says Scott. Keseberg was haunted by allegations of murder and, even worse, cannibalism. Even still, he was able to become a successful brewery owner.

"When he got to Sacramento, he started off doing the things that would equate to mining the miners," Scott explains. "He wasn't hitting the gold fields; he was interested in going into business because he knew there was a market there."

Keseberg would try a number of occupations, including restaurateur and riverboat captain, before settling on becoming a brewer and opening the Phoenix Brewery. Carroll says that the Phoenix may have been the first brewery in Sacramento to make lager beer. However, he admits it's hard to know for sure, pointing to a *Sacramento Union* article titled "A Glass of Lager" that points to another man by the name of A. Schupert as the first to brew lager in Sacramento. To be fair, that article also casts some serious doubt on whether the beer being sold as lager was truly lager at all:

Lager bier, our reader does not require to be told, means long beer, or what we might term stock ale. After it is thoroughly worked or fermented, it should be kept three months before tapping. We doubt if in the majority of instances in California it is kept in the brewery three days. Besides, it is no part of the secret to have it come forth entirely clear, free from fermentation.[5]

Whatever the case, lager beers would become the brew of choice in the region and ultimately the nation.

"You've got Germans, and that's their specialty," Scott explains. "That's what they do; they make lager beer. And then it's popular, it's extremely popular. It's easy to make, it's light, you try to serve it somewhat cooler. Keeping it cold is a challenge. A lot of lager beer establishments are digging cellars to keep things cool. They're also trying to bring in ice."

Keseberg's empire grew. By 1858, he was running a distillery producing brandy in addition to his brewery. He had multiple saloons in the downtown area and employed at least nine people. But within three years, he would lose it all when a great flood in the early 1860s wiped out his brewery.[6]

"That is probably the most notable natural disaster that was going on at the time," Scott explains. "You're kind of at the mercy of weather and fate, whether it be there's a fire, there's the cholera epidemic in the early 1850s."

The weather was a major factor in the production of beer in Sacramento. If you've ever lived through a summer here, you know it can get hot—too hot for most traditional lager beers to ferment properly—and with relatively short winters and little access to ice, brewers turned to a lager style referred to as "steam beer." Steam beer was likely created by a San Francisco brewer, but because it's made using a strain of lager yeast better suited for the warm temperatures, it was ideal for Sacramento beer makers.

Why it was called steam beer is something that's up for historical debate. Some suggest it was called this because it was made using "steam power." But UC Davis's resident brewing science expert says there may be a more romantic reason behind the name.

"Lager is a product style that is associated with colder fermentations," says Charles Bamforth, PhD, DSc, UC Davis's Anheuser-Busch Endowed Professor of Malting and Brewing Sciences and current head of the brewing program. "So the story goes that this lager yeast was fermenting under warmer conditions like ale; therefore, it was a vigorous fermentation, and the fermentations were steaming from the vigor."

(Fun fact: Dr. Bamforth says Kölsh is the exact opposite of a steam beer; it's ale yeast fermented under lager conditions.)

No matter what the reason for naming it steam beer, the style of lager quickly became the beer of choice. "Even in the early days, when only so-called steam beer was brewed, the product of local breweries was not only popular at home, but bore an enviable reputation throughout the entire state, and found ready markets wherever transportation facilities made it possible to ship."[7]

Despite the eventual rise in refrigeration technology and the ability to make the traditional lager, steam beer has survived. More than 115 years later, San Francisco's Anchor Brewing Company still makes its Anchor Steam lager. In fact, Anchor trademarked the term "steam beer," so other breweries now often refer to this style of lager as "California Common."

By 1853, Sacramento was in the midst of a brewery boom of sorts, and these breweries were beginning to have staying power. Part of the reason may be because the breweries were being opened or taken over by people more skilled at business and brewing.

"Accidental brewer" Peter Cadel had opened Galena in 1849, but by 1853, the now dubbed Sacramento Brewery was owned by Philip Scheld. Described as a shrewd businessman, Scheld would make improvements to the brewery, the beer and distribution. "Mr. Scheld's advantages for the manufacture of beer and shipping it throughout California are unsurpassed by those of any competitor in business and enable him to offer better inducements to the trade than can be given by any other market center."[8]

Scheld would also expand his empire, becoming involved in wholesale and retail liquor sales, running a successful saloon, getting into real estate and eventually becoming the director of the Sacramento Savings Bank.[9]

"Scheld came along—who was a brewer, he knew what he was doing—and made it work and made that beer go for a long time," says Scott. Scheld's brewery produced beer until the 1890s, when his brewery and a handful of others in the area merged to form the larger conglomerate Sacramento Brewing Company, something we'll explore more in the next section.

You might think that because of supply and demand and the fact that these guys were peddling what essentially amounts to entertainment, they might be the area's rock stars. But both Carroll and Scott agree that definitely wasn't the case.

"A lot of time the brewers were small," explains Carroll. "In 1860, [there were] maybe seven people at a brewery, and you lived upstairs. It's not glamourous either. People think, 'Oh, you make beer!' but it's not very fun really. Industrial-sized brewing is hard labor."

"They're not going to make a huge living; I think they do it because it is a living," says Scott. "I don't think they are regarding it as anything other than craftsman, akin to a furniture maker, akin to a cobbler, any other craft. If you want to see the true rock stars of that gold rush/antebellum age, it's the saloon owners."

Still, men like Scheld, Louis Nicolaus and Wendell Kerth would leave a lasting mark on the region's brewing legacy. But perhaps none would do so more than Frank Ruhstaller.

FRANK RUHSTALLER: BUILDING AN EMPIRE

"Frank Ruhstaller is kind of an interesting case study because he had nothing when he came to Sacramento," says Scott. "He comes to Sacramento and works his way up and is eventually able to buy the City Brewery on Twelfth and H, and then obviously he builds this empire."

Frank Ruhstaller was born in Switzerland in 1847. In 1862, he came to the United States, moving from New York to Kentucky to New Albany, Indiana. In Indiana before his eighteenth birthday, he was named the foreman at the Paul Reising brewery.[10]

Ruhstaller came to California in 1865. Shortly after he arrived, he made his first appearance on the Sacramento beer scene, taking a job as a foreman at the City Brewery—a brewery he would eventually make his own.

The City Brewery started operations in 1855 around Twelfth and I Streets in Sacramento. The next few years of the small facility's existence are muddied, to say the least. Things begin to clear up in 1860, when Benedict Hilbert and William Borchers are listed as the owners, though the location was different. Some of the confusion is likely in part because of a fire that burned through the brewery in 1859 or 1860.

As it turns out, Ruhstaller only worked at the City Brewery for a year. From there, he went on to brew beer at the Pacific Brewery. The Pacific Brewery opened in 1858 under the ownership of a man named George Ochs. At the time of opening, it was the smallest brewery in the region. Ochs left and came back to the Pacific all within the same year. Once he returned, he worked on expanding the business. In the late 1860s, he hired Ruhstaller to help him brew the beer and eventually made him a foreman.

Ruhstaller worked at the Pacific on and off for several years, returning when the brewery was under the new ownership of Lorenz Knauer. Knauer

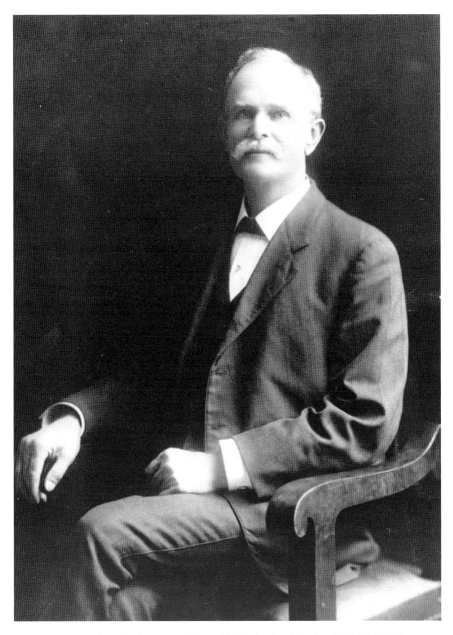

Frank Ruhstaller. *Center for Sacramento History, Todd Ruhstaller Collection, 1987/010/001.*

and eventually his son Frederick transformed the Pacific Brewery into a major player on the beer scene. Here's how it was described in 1880: "The establishment is one of the neatest and best operated on the coast, and Mr. Knauer's experience in beer-making is probably not surpassed by that of any other brewer in the state....There are a few parts of the state which turn out as good a quality of malt liquors as Sacramento, and that of Mr. Knuaer stands high on the list."[11]

Meanwhile, Ruhstaller continued to bounce around, working at different breweries. For a short time, he owned the Sutterville Brewery. He also owned a saloon on K Street. It seems as though Ruhstaller never stopped, and he certainly wasn't afraid of hard work. "He's the kind of person that's not only able to brew, well first of all do what he's told and brew, but obviously he knows how to handle his money because after a while he can buy the place," according to the *Daily Union*.

In 1881, Ruhstaller purchased the City Brewery, where his brewing career in Sacramento had begun. It turned out to be a historic purchase for the Sacramento area even if at the time it received little attention in the papers: "Wm. F. Borchers to F. Ruhstaller—November 23, 1881; grant; lot 10, between G and H, Twelfth and Thirteenths streets, Sacramento."[12]

Ruhstaller immediately made changes at the City Brewery (most notably, he built a larger and more productive brewery) and in the beer-making world. He embraced innovation and technology in his beer-making process. He broke ranks with the brewers' association and supported the unionization of brewery workers.[13]

At the City Brewery, Ruhstaller introduced his Gilt Edge Steam Beer. It became his flagship brew, and he promoted it everywhere, from signs hanging in saloons and stores to ads in the paper. The campaign was so memorable that his marketing acumen was mentioned in his obituary: "Mr. Ruhstaller by turning out an excellent quality of beer and by judicious advertising built up business hardly second to any in the state."[14]

"It's the personality, the charismatic guy, it's the hard worker, it's the guy who won't be denied, it's that person that's going to succeed. And of course, after a while, what else is there. He's able to crush so many other brewers in the area," says Scott.

Frank Ruhstaller wasn't just about making beer. He appears to have been a family man, marrying Charlotta Oeste on Christmas Day 1870. They had at least five children, including Frank Jr., who would eventually take over the family business.[15]

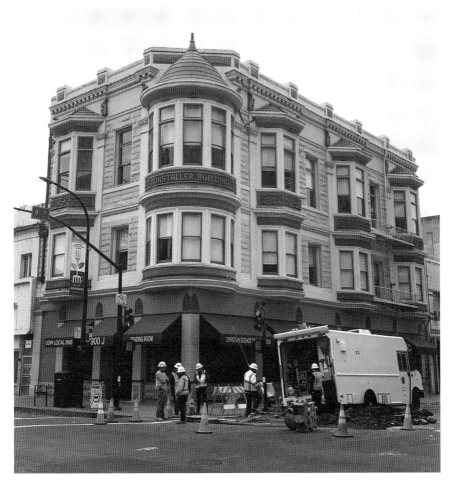

The Ruhstaller building in downtown Sacramento. *Author's collection.*

Ruhstaller was an active member of the community. He is often referred to as "Captain Ruhstaller" because of the rank he achieved with the Sacramento Hussars. He was also an avid sportsman, belonging to several gun clubs, and was the owner of Sacramento's Gilt Edge Baseball Club, which won three straight championships in the late 1890s. "'Cap' Ruhstaller was one of the most enthusiastic backers of the Gilt Edges, and it was principally due to his generosity that the club was able to enter the California State league properly financed."[16]

Ruhstaller built up his wealth and stature in the community, at one point even turning down the nomination to become Sacramento's sheriff.[17] He

was the president at the Fort Sutter National Bank. He invested in real estate, including the Capital Hotel and what is now referred to as the Ruhstaller Building on Ninth and J Street in downtown Sacramento. It was likely from there that he would achieve his greatest accomplishments in the beer world.

THE RISE OF THE BREWING INDUSTRY

By the late 1800s, brewing had gone from a neighborhood profession to a national industry. The advent of pasteurization allowed beer to be shipped long distances without spoiling, and the advances in technology such as artificial refrigeration, refrigerated railcars and rail side icehouses were changing the way beer was made and shipped.

All of this would give rise in 1876 to the nation's first national beer brand: Budweiser. Bud maker Anheuser-Busch grew fast. By 1901, the company sold more than one million barrels of beer for the first time.[18]

By the 1870s, Budweiser was already being sold in Sacramento-area saloons, and local brewers were taking notice. By the late 1880s, brewers like Ruhstaller, Scheld and others realized that the only way to survive the rising production costs as well as the national competition was consolidation.

Around this time, a man named Herman Grau came to Sacramento. The German-born Grau moved to Buffalo, where he worked at a brewery that burned down not once but twice. With that brewery in ashes, he moved to Sacramento, where he partnered up with another Buffalo transplant, Emil Gerber. Gerber was entrenched in the community, already serving as Sacramento County auditor. The pair decided they would build a brewery to a scale not before seen in Sacramento, one that could compete on a national level.

To achieve their brewery, they needed money. For that, they turned to fellow brewers, including Philip Scheld and Frank Ruhstaller (Ruhstaller invested $10,000 alone).[19] They also got investments from other high-ranking community and state leaders. All of this would lead to the launch of the Buffalo Brewing Company on August 31, 1889. A public grand opening was held on May 9, 1890. "The stockholders and employes [*sic*] of the company will be pleased to show our guests through the brewery. It should be understood that the invitation extends to the ladies, and no disreputable characters will be allowed, either on the brewery premises or the grounds."[20]

Buffalo Brewing was like nothing the city, state or entire West Coast had ever seen. The production facility represented the largest brewery ever built west of the Mississippi. Out of the gate, it could produce sixty thousand barrels of beer, but it was designed to do even more. "This company, commencing to brew in December, 1890, began at once the brewing of a beer which it was designed to render the superior of any other local or state production."[21]

The beer was an almost immediate hit. Almost a year to the day after the launch, the demand for Buffalo led to the opening of a storage facility and general office in San Francisco.[22] "The success already met with is attributable to the thoroughly experience[d] management and the excellent plan, which is the most complete and modern one of the United States."[23]

The success was just getting started. Buffalo's Edelbrau, German for "noble brew," would prove to be an international success. "The popularity of 'Edelbrau' has extended far beyond the boundaries of this state, and many demands from Honolulu, Japan, South and Central America are swelling the orders coming in daily from parts of the Pacific Coast."[24]

While this was happening, the owners of the small Sacramento breweries were recognizing the necessity of consolidation in order to stay both competitive and in business. In May 1892, under the leadership of Frank Ruhstaller, the City, the Sacramento, the Union and the Pacific Brewery consolidated to form the Sacramento Brewing Company.[25]

The agreement stated that the small breweries would either contract brew for the newly formed Sacramento Brewing Company or stop brewing altogether. So consider this for a moment. Frank Ruhstaller was simultaneously the vice president of Buffalo Brewing Company and the head of the Sacramento Brewing Company. He essentially controlled or had partial control of the two largest breweries in the city. He was literally the king of Sacramento beers.

Not too surprisingly, the two breweries themselves consolidated. Sacramento Brewing Company kept its name, but all properties would belong to Buffalo. This was a pretty good deal for everyone, since both companies shared a number of investors.

That didn't mean Ruhstaller was done. In 1905, he built a new brewery to replace the City Brewery, calling it the Ruhstaller Brewery. By this time, the area's other breweries had basically gone out of operation. The timing of this is somewhat notable because two years later, Ruhstaller died from heart problems.

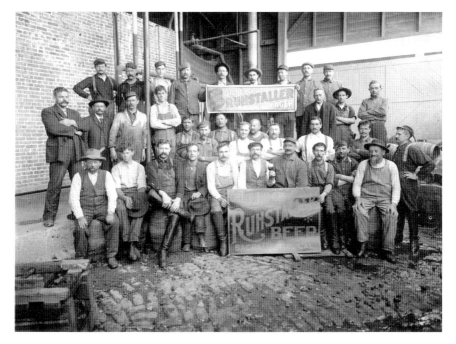

Employee photo from Ruhstaller Brewing Company, circa 1889. *Center for Sacramento History, George Kosterman Collection, 1967/046/007.*

Frank Ruhstaller Jr. picked up the family business and, in 1913, became the president of Buffalo Brewing Company following the death of the company's first president, Adolph Heilbron. "Frank J. Ruhstaller inherits all his father's genius as a brewer, combining the attributes of a thorough financier and business man."[26]

The junior Ruhstaller held the title of Buffalo Brewing Company's president until he retired in 1939 after navigating the brewery through Prohibition. When Prohibition was enacted in 1919, it must have come as a great surprise to many. Just read what Buffalo Brewing Company manager Colonel H.I. Seymour wrote in the *Sacramento Union* just ten years earlier:

> *Prohibition is an impossibility, by reason of inherent traits in the human make-up. True temperance is a possibility and should be wisely fostered. As people learn to drink and how to drink real progress is made. Statistics prove that the beer drinking people of the world are the most intelligent, the most progressive, the hardiest and thriftiest. They are also the most temperate.*[27]

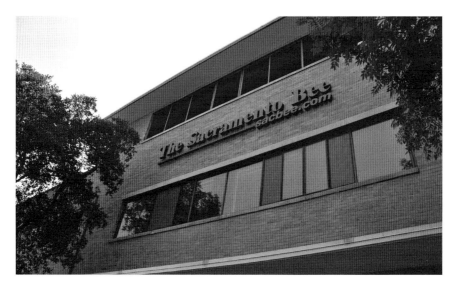

The *Sacramento Bee* is now located where the Buffalo Brewing Company once stood. *Author's collection.*

With Frank Ruhstaller Jr. at the helm, Buffalo Brewing Company actually survived Prohibition by manufacturing ice and focusing on near beer. When Prohibition was lifted in 1933, Buffalo went right back to producing real beer.

That didn't last long. In 1942, the owners announced they would cease operation but that the name would live on after being purchased by Grace Brothers Brewery of Santa Rosa.[28] Grace Brothers actually brought the brewery back on line in 1944, citing "unprecedented wartime demand,"[29] but that was short-lived, as it ceased operations for good in 1945.

In 1949, the owners of the *Sacramento Bee* announced they had purchased the property where Buffalo Brewing stood for $275,000. Grace Brothers announced Buffalo Beer would from then on be produced in Los Angeles, meaning Buffalo was no longer a Sacramento beer.[30]

Today, the *Sacramento Bee* still stands where Buffalo once did. There's very little, if anything, to suggest that the location was once home to the largest brewery west of the Mississippi.

Sacramento had been home to commercial brewing for more than one hundred years when the last commercial brewery closed in 1965. It would be fifteen years before brewing would come back to the city and almost half a century before the number of breweries in this region would once again match that of the gold rush era.

HOP HISTORY

One must not rush into the hop business blindly, as it requires some capital and good practical farming sense; but because the soil in the Sacramento Valley is so rich, and contains the proper nutriment for hops, and you can grow so much more per acre than elsewhere—therefore cheaper—the logical place for you to start your hop yard is in the wonderful Sacramento Valley, California.[31]

One of the advantages guys like Frank Ruhstaller and Peter Cadel had while brewing beer in Sacramento was access to fresh, locally grown ingredients. This is particularly true of hops, which would be its own burgeoning industry. And as that 1908 article from the *Sacramento Daily Union* explains, it shouldn't come as a surprise. Hops need three things to grow: water, sun and fertile soil. These are things that you can find in abundance in the Sacramento Valley.

"Can you think of a better place to be able to grow hops, to grow barley, to grow raw material for beer?" asks Sacramento historian James Scott. "We are sitting in what used to be an inland ocean. As time moved on and the water receded, you had these alluvial fans that were pushing out the richest soils from the Sierra Nevada. You've got Stone Creek, Cache Creek, Dry Creek being these depositors of fine soil, and what we end up with is this great black soil."

"Like wine, like a lot of other produce—walnuts, tomatoes, peaches, whatever—they [hops] don't grow everywhere, and it's the unique opportunity that we have in Sacramento that not every community or every

town in the world has," says Ruhstaller Brewing Founder and modern-day hop grower JE Paino.

So ripe are the conditions to grow hops in the Sacramento Valley that farmers yield crops in the first year of planting, compared to eastern hop yards, which typically take three years before producing a full crop. And it wasn't just the soil. The weather was perfect—warm and dry, allowing California to avoid mildew.

Because of that, by the turn of the century, the Sacramento region was the number-one hop-growing region in the country. How good? Look at this blurb from the *Healdsburg Tribune* in 1920: "Encouraged by the ready market and high prices for hops last season, growers in the Sacramento Valley will put 1,500 acres of new land into hops this year, making a total of 6,500 acres. Practically all of the valley's $4,000,000 hop crop was exported last year."[32]

Two impressive numbers stick out there. First, by 1920, there were around 6,500 acres of hops in the Sacramento Valley. Second, those hops were lucrative, raking in $4 million. That's a lot of money in 2017; imagine how far that money would go in 1920.

So how did the Sacramento region become the nation's hop hotbed—and where did the industry go? Well, you could probably fill volumes of books with those answers. I'm going to attempt to give you a brief explanation.

Beer Pairing: If you're going to discuss hops, it only makes sense to drink something particularly hoppy. For that, I'm going to turn to one of the hoppiest beers I've had in the region: Knee Deep's Simtra Triple IPA. Also, speaking from experience, if you're going to drink the twenty-two-ounce bomber, be sure you don't have anywhere else to be.

IN LIKE FLINT

If you're reading this book, chances are you are quite familiar with the idea that hops are a key ingredient to beer. They're what give beer its flavor, aroma and personality. The problem for early gold rush brewers was the lack of accessibility of good hops.

Most hops were imported from Europe. At the time, the only hops grown in the United States were in New York. Neither of those locations is particularly close to California, so the brewers never knew what kind of

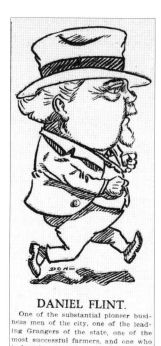

DANIEL FLINT.

One of the substantial pioneer business men of the city, one of the leading Grangers of the state, one of the most successful farmers, and one who is largely engaged in hop culture.

Editorial cartoon and drawing of "Father of Hops" Daniel Flint in the December 31, 1908 edition of the *Sacramento Union. California Digital Newspaper Collection, Center for Bibliographic Studies and Research, University of California, Riverside.*

quality to expect when the hops arrived. In the late 1850s, this would change when Daniel and Wilson Flint imported hop roots into the state. Daniel Flint explained this in an editorial in the *Pacific Rural Press*: "My brother, Wilson Flint, imported the roots from Vermont and propagated them for two or three years in the town of Alameda. In the winter of 1857–1858, we moved our nursery to Sacramento, and I began the hop culture in the spring of 1858."[33]

The Flint brothers operated a sixteen-acre farm south of Sacramento. Daniel Flint referred to himself as the "pioneer hop grower of the Pacific States," pointing out that he not only planted them first but also had the first kiln and press on the coast. "Until better proof is produced, I shall still sign myself Daniel Flint Pioneer Hop-Grower of Pacific Coast."[34]

Flint seems to be as possessive of the title of "pioneer" as he was generous with his hops. After his success with hop growing, others wanted to get into the hop business, and Flint supplied them the hop roots. One year, he reported selling more than $3,000 worth of hop roots. In fact, while Flint built the industry, he may have also taken the first steps toward killing it by selling the first hop roots ever grown in Oregon and Washington.

Flint's very first crop sold for one dollar a pound but didn't exactly take off. It would take about a decade before California hops were properly recognized for their quality, but even by 1880, hops from California, Oregon and Washington accounted for less than 10 percent of the country's hop production.

"For a while, all the hops were from back east," Carroll explains. "People didn't trust new hops in California, so they're still buying the stuff, even though the best hops was coming from right across the bay in Alameda, up by Livermore and up here of course, too."

Flint talked about the difficulties he found early on in the hop industry market in an 1881 editorial in the *Pacific Rural Press*:

I not only labored under great difficulties in not knowing how to plant, cultivate, pick and cure the hop, the buildings and press that it required, but I found the trouble in selling them more formidable than growing.

The only way I could sell my hops was by going to the brewers and offering them a great deal less than the dealers were asking for the imported article. That method set some of the brewers to thinking, and I got them to try them by putting in one-quarter to one-third of California hops with the eastern to a brewing. Soon the dealers saw they had to have some California hops to supply their customers, or else they would loose [sic] them. [35]

His method must have worked. By the 1870s, California hops were bringing in a better price than those raised on the East Coast. By the 1880s, the quality of California hops was known worldwide. And by 1893, the Pacific coast was outproducing growers in the East. [36]

So it's no surprise that hop growing across the Sacramento region was booming. "Especially in the immediate Sacramento area, you're looking mostly at Sacramento State, where Sacramento State would be today," says Scott.

That's right—where Sac State stands now was entirely hop fields, along with areas like Sloughhouse and Fair Oaks. The industry here was strong for decades, with locals still remembering the hop yards.

"People that have been out in Fair Oaks Boulevard and Sac State before it was a university know it was all hops," says Paino. "People that have been around for a couple of generations, they remember going out to grandma and grandpa's house and seeing it and just being blown away by it."

And it wasn't just Sacramento. In fact, the area's largest hop fields were found in Yuba County. By 1889 and 1890, Yuba County was responsible for growing more hops than any county in the nation. [37] "The first experiment with hops in Yuba County was made in 1883 by Dr. D.P. Durst, and today there are over 1000 acres in the immediate neighborhood of Wheatland, and each succeeding year sees it increasing." [38]

Dr. D.P. Durst is an important name to remember. When the above-quoted article was written, the so-called Hop King had left his 350-acre farm in Wheatland to his sons. The Durst Hop Ranch yard was considered the largest in the world, coming in somewhere between 600 and 800 acres, depending on which reports you believe. While Durst did not bring hops to California, he left a lasting legacy in changing the way they were cultivated.

Walter Wissemann hop ranch, circa 1915, where you can see the trellis system being used that was first developed at the Durst Hop Ranch in Wheatland. *Steve Abbott Collection.*

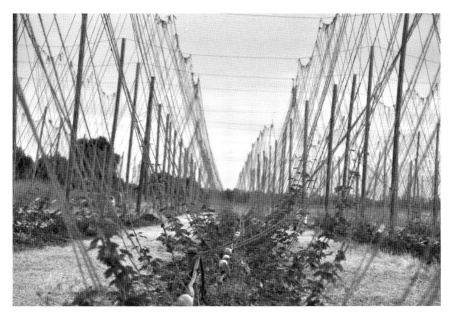

Hops growing in 2017 still using the same type of trellis system developed in 1884. *Author's collection.*

> *The system of trellising hops was patented in New York some years ago,*
> *but the experiment proved a failure, as there is now no trellis-work in New*
> *York, or any of the other Eastern yards. But a New Yorker, Logan by name,*
> *who happened to be in the yard of D.P. Durst, of Wheatland, in the year*
> *of 1884, gave Mr. Durst the idea of a system of trellising, and, putting*
> *their heads together, they concocted a system which is a success and which is*
> *rapidly replacing the willow-poles in all the hop yards.*[39]

The article goes on to explain that this trellis system used sixteen- to twenty-foot wooden poles set in a sort of grid pattern, with larger poles being used on the outside, buried deep and set at an angle, because these poles bore the brunt of the weight. Heavy wire was strung across the poles, with a heavy twine or light wire tied to cross-wire and anchored to the ground. Hop vines would then be trained to grow up these strings. The system that Durst created in in 1884 is basically the same system used by hop farms around the world for more than 130 years.

The Durst farm would also leave a lasting legacy in hops history for a very different reason. It was the scene of a deadly labor dispute.

WHEATLAND HOP RIOTS

Aside from rich soil, water and sun, the other thing you need to grow and process hops is manpower. Think about it: every acre of hops is equal to hundreds of hop vines. By the mid-twentieth century, most picking had been mechanized, but in the early 1900s at many farms, it was all done by hand, and that meant the need for thousands of laborers.

An idea of a typical hop picker's day comes from an article in the *Press Democrat* in 1912 about a hop harvest in Sonoma:

> *There is no organized labor in the hop fields; the hours range from 4, 5, 6*
> *or 7 o'clock in the morning, according to the ambition of the picker, to 5 or*
> *5:30 in the evening. Some of the more industrious pickers begin at as early*
> *as 3 a.m., and pick by lantern light, which is one of the novel sights of*
> *the fields. The lightest and slowest pickers earn from $1.50 to $2.00 per*
> *day, while this year, the majority of pickers averaged from $5.00 to $5.50*
> *per day.*[40]

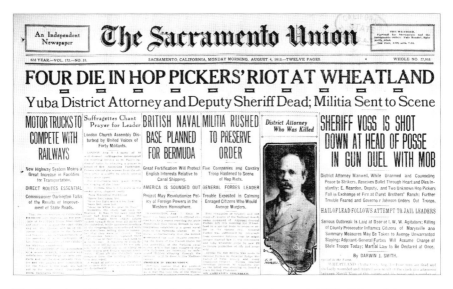

The Wheatland Hop Riots make the front page of the August 4, 1913 edition of the *Sacramento Union. California Digital Newspaper Collection, Center for Bibliographic Studies and Research, University of California, Riverside.*

That brings us back to the Durst Hop Ranch in Wheatland. In the summer of 1913, Ralph and Jonathan Durst advertised for workers to pick hops. During the harvest season, the Durst ranch was the largest employer of agricultural workers in the state, with somewhere around three thousand to five thousand people, including men, women and children of all nationalities.[41]

Here's how the group was described in the Sacramento Union that came out the day of the hop riots: "Often whole families take part in the picking and come from hundreds of miles to take part in the work. They are of all nationalities and all ages and both sexes and form one of the most cosmopolitan and promiscuous crowd[s], from every standpoint, that can be found anywhere on earth."[42]

In early August 1913, about three thousand people showed up at the Durst brothers' farm to pick the hops. To ensure that the workers stayed the entire stretch, instead of paying the standard $1.00 per 100 pounds picked, the brothers devised a sort of pay scale system. Under this system, workers would earn $0.90 per one hundred pounds of hops picked during the first week, $1.00 per one hundred pounds the second and $1.10 per one hundred pounds the third. The only way to make a full salary was to work all three weeks.

Because workers labored sunup to sundown, the Dursts allowed them to stay at a workers' camp. It was the camp that created the most significant problem, and it's easy to see why. In the days following the riots, a state inspector surveyed the camp. His results were published in the *Sacramento Union*:

> *I found the camp on a sun-baked lot, in old tents that had been used for years, consisting of poles with burlap tied around them. At several places in the camp water was allowed to stand long enough to get stagnant, close to the pump that supplied drinking water for the people of the camp. The toilets, about twelve in number (being an increase of six since August 4) are close to the water that the people drink from.*
>
> *There is no sewage system of any kind and the sewage from the kitchens of the several camps is allowed to run in an old irrigation ditch.*[43]

The report also said that field workers were only getting water twice a day, despite temperatures reaching well over one hundred degrees. This was disputed by others saying no water was offered, and instead the Dursts were selling a mix of water and acetic acid for five cents. The Dursts also operated a market that sold food to the workers at a price well above market value.

So it should come as no surprise that within a day or two, workers, with the help of the Industrial Workers of the World (IWW), were ready to take action. On Sunday, August 3, 1913, a committee led by Richard "Blackie" Ford confronted Ralph Durst, demanding better living conditions, access to fresh water in the fields and higher wages or else the workers would strike.

> *A rat-faced, derby-wearing, cigar-chomping manager, Durst halfheartedly agreed to all demands except the wage increase. When told by Ford that there would be a strike, Durst charged at him and slapped him across the face with a heavy work glove. He then ordered him and the other marchers off his property. They refused to leave.*[44]

Durst then went looking for District Attorney Edmund Manwell and Yuba County sheriff George H. Voss. They formed a posse that returned to the Durst ranch to evict the striking workers. The groups immediately clashed.

> *The district attorney talked for peace, and attempted to arrange the difficulty with the men, but they were belligerent and wanted to fight, According to witnesses to the trouble, when some of them, said to be members of the Industrial Workers of the World, became violent, the sheriff attempted to arrest them, and there was an immediate scuffle.*[45]

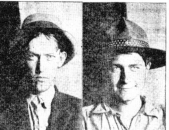

Ford, Suhr, Bagan and Beck Are Formally Charged With the Murder of E. T. Manwell at Wheatland Last August.

Mugshots for Blackie Ford, H.D. Suhr, Harry Bagan and William Beck in the *Sacramento Union* during the murder trial following the Wheatland Hop Riots. *California Digital Newspaper Collection, Center for Bibliographic Studies and Research, University of California, Riverside.*

"Scuffle" is an understatement, as gunfire followed. In the end, D.A. Manwell, a deputy sheriff identified as E. Reardon of Wheatland and two workers, only identified as a Puerto Rican and a Mexican, were killed. Sheriff Voss was shot and badly beaten. Three other men were also shot.

Blackie Ford, H.D. Suhr, Harry Bagan and William Beck were arrested and tried for the murder of the district attorney. Yuba County prosecutors called it the "most important trial ever held in the history of this county." They argued that even though it was said that the unidentified Puerto Rican pulled the trigger, the union organizers were the cause of the riot and thereby responsible for the deaths of the district attorney and the sheriff's deputy. Defense attorneys argued that the conditions at the Durst ranch were deplorable and that the actions of the sheriff were unjustifiable.[46]

Witnesses testified that Ford perpetuated the violence, telling the crowd, "Let the officers fire first, and we will finish it." Suhr was accused of encouraging other members of the IWW to gather for the strike and helping to fund the protest.

The trial lasted about a month, appearing on the front page of the paper just about every day. On January 31, 1914, after nearly twenty hours of deliberation, the jury found Blackie Ford and H.D. Suhr guilty of second-degree murder but acquitted Harry Bagan and William Beck. Ford and Suhr were sentenced to life, though they would only serve a little more than ten years in prison before being paroled in 1926.

The Durst ranch went on producing hops for a few more years following the riots. In 1915, the ranch was sold and subdivided, ending its run as one of the largest hop ranches in the world.

The Wheatland Hop Riots are considered one of the country's first labor disputes. They raised the profile of the laborer and were the catalyst for some of California's first labor laws.

Where Did the Hops Go?

The Wheatland Hop Riots of 1913 were certainly a black eye on the hop industry but did little to slow it down. The turn of the century saw California's hop industry continue to grow. California was the nation's top hop-producing state from 1915 until 1922. During that time, California was cranking out around 50 percent of the total U.S.-grown hops. But trouble was on the horizon.

Around that same time, Oregon's and Washington's hop industries were rising, and Prohibition was coming into effect. "Prohibition took a pretty big bite out of the whole industry. It wasn't really felt right when Prohibition happened, but it took some time," says California agriculturist and agricultural historian Rory Crowley.

In the book *Tinged with Gold: Hop Culture in the United States*, Michael A. Tomlan points out that California growers were some of the hardest hit by Prohibition, and there were just ninety-three farms producing hops by 1929. A decade later, he says, hops were only growing in three California counties, though Sacramento was still one of them.

"There were some factors that led to the decline of hops in California, and there were some significant ones," Crowley says. Among those, he points to labor shortages following World War I and especially World War II. And he says California growers simply turned their attention to other crops.

"A significant part of hops falling out of favor was just the fact that we could grow trees really, really well here. And tomatoes. And strawberries," says Crowley. "So other higher-value crops went into the ground as opposed to hops."

Another major factor was the rise of Northwest hops. While the number of hop growers was dwindling in California during Prohibition, it doubled in Oregon. By 1939, Oregon was growing roughly half the nation's hops, with California and Washington splitting the rest. Just four years later, Washington surpassed Oregon's production, making it clear the Northwest had become the true king of hops.

Crowley says perhaps the most significant blow to California's hop industry didn't come until the 1980s with the release of the "Big C" hops: Chinook,

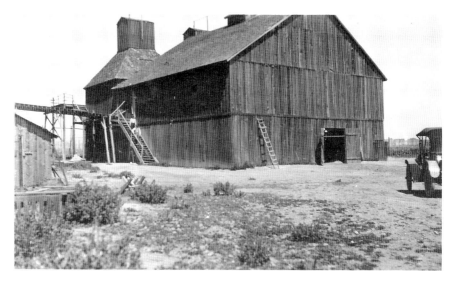

One of the hop-processing facilities at the Wissemann hop ranch. *Steve Abbott Collection.*

Cascade and Centennial. Crowley refers to these as the "workhorses of the industry," as they are the standard hops used by everyone.

"All of these factors really started contributing to the centralization of mechanization and infrastructure in the Pacific Northwest, particularly because these hops were nominally better suited for those types of climates," Crowley explains. "And at that time, specifically back in the '80s, we were more focusing on walnuts, peaches, almonds in particular; that was when we had our big almond boom."

With the desire to grow hops diminishing and the Pacific Northwest beginning to corner the market, it's pretty obvious that the industry here was going to dwindle. How far has it dwindled? Remember that article from 1920? It listed the total acreage dedicated to hops in the Sacramento Valley alone at 6,500. Today, there are fewer than 300 acres of hops in the entire state.

Here's another way to look at it. An August 2017 hop report from the National Agricultural Statistics Service, Agricultural Statistics Board, United States Department of Agriculture, forecasted roughly thirty-nine thousand acres of hops being harvested in Washington, more than eight thousand in Oregon and even seven thousand in Idaho. California wasn't even listed.[47]

But there might still be hope for hops. It's a topic we'll explore more when we look into the future of beer in the Sacramento region.

PART II

THE PRESENT

CHAPTER 3

THE CRAFT COMEBACK

Before you can really delve into the explosion of craft beer in the Sacramento region, it's important to understand craft beer in California. Starting with some important milestones:

1965: Fitz Maytag purchases San Francisco's Anchor Steam Brewing Company, the only craft beer operation in the state.
1977: New Albion Brewing Company opens in Northern California. It's the first modern microbrewery in the country.
1980: Beer legend Ken Grossman opens Sierra Nevada.
1982: Legislation is passed to legalize brewpubs (this is a big one!).
1983: Mendocino Brewing Company opens in Hopland. It's the first brewpub in California and the second in the nation.

Mendocino's opening didn't exactly lead to a craft beer boom. According to the California Craft Brewers Association (CCBA), in 1990 there were fewer than 70 breweries in the state. Think about that; that's fewer than 10 breweries opening every year since the legalization of brewpubs. By the year 2000, just ten years later, that number had nearly tripled to around 200 breweries, with the pace picking up to around 13 new breweries opening each year. Then things would slow down, most likely because the nation was in the worst recession in decades. By 2012, the number of breweries in the state would only climb to 313, the pace right around where it was in the '80s. And then…BOOM! In late 2017, the CCBA reported that number

had grown to 900. In just a five-year span, nearly 600 new breweries had opened their doors.

"Craft beer really exploded, I feel like, in the last thirty-five years. It's been steady; there's ups and downs, but it's been a steady growth really since it began," says CCBA executive director Tom McCormick. "We've just had a big, big surge in the awareness of what craft beer is in the last five to ten years by the consumer."

"It's actually been pretty global," says Sierra Nevada founder and craft beer legend Ken Grossman. "The U.S. marketplace has gone from roughly forty brewers, when I first started in the late '70s, early '80s, to many thousand today; six thousand or so either operational or in planning."

And in no place has that been truer than in the Sacramento region. For most of the past thirty-five years, this region was home to only a handful of breweries at any given time. And every single one of them was a brewpub.

Blair Robertson was a longtime restaurant critic and beer beat reporter at the *Sacramento Bee*. He arrived at the paper in 1999. "When I got here, everything seemed to close at nine o'clock. There wasn't a lot of excitement about craft beer right then. There was sort of a malaise."

But in the last decade, that malaise has given way to an explosion. There were just about ten local breweries in the region by the end of 2009. By

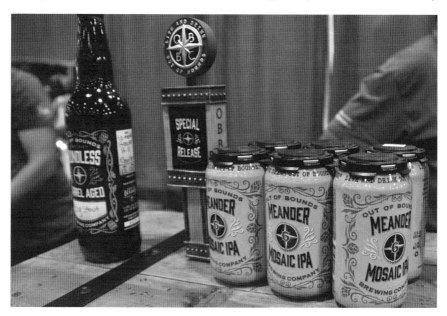

Beer from Out of Bounds Brewing Company, one of the many successful breweries to open in the last few years. *Author's collection.*

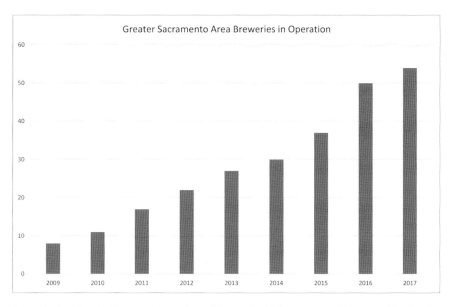

A graph showing the increase in number of breweries in Sacramento. *Sacramento Beer Frontier.*

the end of 2017, the number was nearly sixty. Even with the closures of breweries like the Rubicon, Dragas and American River, the number continues to grow.

"The growth spurt in Sacramento is relatively late to the game," says McCormick. "It was the Bay Area, and then San Diego blossomed and now Sacramento has blossomed. Sacramento's a little bit late to the game, but it has definitely arrived. It is here."

I LOVE THE '80S

Before you can get to the modern craft beer boom in the Sacramento region, there are some important events and people you must get to know from the 1980s.

We'll start with a Sacramento man named Jim Schlueter. In 1980, he opened River City Brewing Company, which is considered the area's first modern microbrewery. (This is not connected to the River City that is still open in Sacramento today.) Schlueter's River City was an immediate success, winning several awards and at one point reporting that it was producing

sixty thousand gallons of beer per year. However, River City was open for fewer than five years due to mounting debt.

"Our debt load was just too high for our sales and it was impossible to go forward," Schlueter told the *Sacramento Bee*.[48]

In 1982, then governor (and oddly enough current governor) Jerry Brown signed Assembly Bill 3610 to amend the state laws to remove restrictions on on-premise sales of craft beer. This gave way to the birth of California's brewpubs.

The first California brewpub opened the following year when Mendocino Brewing Company began brewing beer and serving food in Hopland. Buffalo Bill's in Hayward opened in 1984, followed by Triple Rock Brewery in Berkeley in 1986.

That brings us back to Schlueter, who, despite going bankrupt with River City Brewing, opened this area's first brewpub in 1986 with Hogshead Brewing Company in Old Sacramento. Interestingly, he sold the Hogshead a few years later and opened yet another brewery, this time Dead Cat Alley Brewing Company in Woodland (just down the street from where Blue Note Brewery is located now).[49]

Shortly after Hogshead opened, Ed Brown opened the Rubicon. And while it wasn't the first brewpub to open in this region, it would blaze a trail for the craft beer movement in Sacramento and beyond.

Beer Pairing: The only appropriate beer to have with this section is the one that put Rubicon on the map: the Rubicon IPA (hopefully when you're reading this, it's still being made).

RISE (AND FALL) OF THE RUBICON

When Ed Brown opened the Rubicon in 1987, you might have thought he was just following a brewpub trend. As it turns out, he didn't even know those other brewpubs were open. He says he got the idea to open a pub while traveling in Europe.

"I noticed all these small breweries around, not necessarily brewpub types, but small regional breweries, and I thought, 'This is pretty cool. I wonder why we're not doing this back home?'" Brown says. "I came back and found out that it was starting to happen here."

It was 1986, and Brown had been living in Sacramento for several years. He had originally moved to Sacramento while working for a real estate developer and fell in love with whitewater kayaking and a girl. So, it was a no-brainer when the company said it wanted to move him to LA.

"I said, 'Well, it's been fun but no thanks, I'm not going to LA,'" he laughs. "I got a job with a bank up in Auburn; I worked there for five years. And somewhere along the end of those five years is when that England trip happened and I got the seed planted to check brewing out."

With a fresh bite from the brewery bug, he talked to the owners of Triple Rock, and he says Bill Owens of Buffalo Bills was a real inspiration and supporter. "When I started this place and opened it, I invited Bill, and he came in and goes, 'This is the best one ever!'" Brown lights up when he talks about the early days of the Rubicon. He has an infectious personality, and it seems that everyone wants to talk to him when he walks into the room. It's easy to see how he was able to open and run Sacramento's oldest brewery.

Now convinced he would open his own brewpub, Brown visited a brewery out of state that he describes as having a really cool space in a warehouse and decided that was the feel he wanted for his own business. Despite hiring

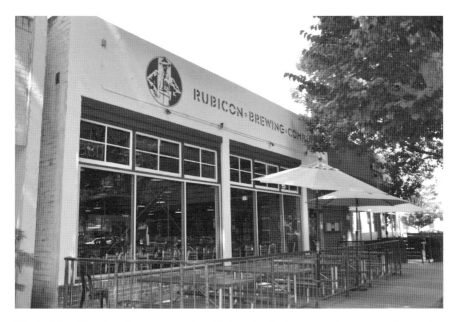

The Rubicon Brewing Company stood at this location in downtown Sacramento for nearly thirty years. *Author's collection*.

a realtor to find a location in Sacramento, he says he found the spot for the Rubicon at Twentieth and Capitol all on his own. It's important to remember this was 1986, and Midtown Sacramento was not the trendy hot spot that it is today, but it was good enough.

"There was enough going around. There were state workers, and there was enough of a neighborhood around it that I thought it could support it." But Brown admits the location did have its drawbacks, "When I started the Rubicon, I had to kick bums out of the doorway when I came in in the morning."

Starting a brewpub is basically starting two separate businesses at once. You have to have some idea of how to run a brewery, and you have to have some idea of how to run a restaurant. Brown really didn't know how to do either. He also didn't have a lot of money to work with. "I think I did this place on $480,000. It doesn't sound like much, but back then it was a lot of money. I mean, it's still a lot of money, but you couldn't do this today for $480,000."

With his self-described shoestring budget, Brown needed help to get the Rubicon off the ground. It turns out the people who played the biggest roles in the Rubicon would also play huge roles in shaping craft brewing in California and, in one case, the country.

Brown had done some home brewing and had even started to take classes at UC Davis. There, he met UC Davis's famed brewing science professor Dr. Michael Lewis. Aside from revolutionizing brewing education, Dr. Lewis was also a visionary able to see where the brewing industry was headed before it got there.

"Back in the day, one of the things small brewers could not get was equipment. So aside from starting the Master Brewers Program, I also started a fabricating company for making equipment, and the Rubicon brewery was one of the first units that we built and installed," Dr. Lewis says.

"He designed the brew house, and that was like the prototype for that sort of brew house," Brown says.

"The brewery I built for Ed was the forerunner of the design that I rebuilt many times. The plumbing ideas were all there; the idea of the mash tun over the hot-water tank, separate kettle and so on and the valving system in front. All of the equipment I built had that fundamental structure," Dr. Lewis says of the thirty-year-old system that's still in use today. "It's still operating; you can't knock that!"

Opportunity would knock again for Brown—or rather, it would walk in through the front door. "I started to realize that I probably wasn't going to

manage this place and do the brewing," he says. "I was here, I forget what I was doing, a guy named Phil Moeller came in, and he just looked at me and he goes, 'I'm going to be your brewer.'"

A renowned home brewer, Moeller took the reins as the Rubicon's head brewer. He created Rubicon's signature IPA, which won the very first gold medal for IPAs at the Great American Beer Festival in 1989. It would do it again in 1990.

"This place is still the only brewery besides Firestone that has won two gold medals in the same category two consecutive years," Brown says proudly. But the IPA did more than that. "I think the Rubicon pretty much introduced IPA to Northern California."

Not only did it introduce that style of beer, but it really become a gateway for beer drinkers. Craft beer enthusiasts across the region credit the Rubicon IPA for showing them that beer could have flavor. The hop-forward brew was a drastic departure from the Budweiser, Coors and Pabst that dominated the market at the time.

Moeller is also credited with creating Wheat Wine during his time at the Rubicon. Legend has it he was trying to make a barley wine when he added too much wheat to the mash tun. The resulting brew was high in alcohol but also complex in flavor. It's a beer that would earn Rubicon medals at the Great American Beer Festival in 2016.

Moeller left after just five years, but not before training his replacement, Scott Cramlet. While having big shoes to fill, Cramlet went on to make his own mark on the Rubicon by creating the brewery's most unforgettably named beer: Monkey Knife Fight. It's a pale ale that, like the IPA, many beer drinkers point to as their gateway into craft beer.

"There was never any problem getting people to drink good beer," Brown says with a little snicker. Educating people about that beer, though, was a different story. "It took a generation to educate people. People who were customers here used to bring in their kids. Their kids grew up here, and now their kids are of drinking age and they're leading the way of drinking these better-quality craft beers."

Brown had his brewery and groundbreaking beer, but there was still the issue of running a restaurant. For that, he would turn to a friend of the family. That family friend was Gary Fish—the same Gary Fish who started and owns the wildly successful Deschutes Brewing Company.

Fish's and Brown's fathers were business partners. Fish had spent his life to that point in the restaurant business, so Brown turned to him for help. "I called him and said, 'I got this idea, but I know nothing about the restaurant

business. Do you want to come and help me get this going?' And he did. He kind of helped me with the food end operation of it."

In turn, Brown says he helped teach Fish (or Fish learned along with him) the ins and outs of operating a brewery. "I offered to work for Ed, basically for free, just so I could learn about the micro and pub industry," Fish said in a 1999 article with *Modern Brewery Age*.[50]

Fish didn't stay long, leaving for Bend, Oregon, to start Deschutes in 1988. Nearly thirty years later, Deschutes was ranked the eightieth-largest craft brewery by volume in the country by the Brewers Association.[51]

Meanwhile, Brown went on to own the Rubicon for eighteen years before selling in 2005. "After twenty years, I was pretty much done." Despite getting out nearly a decade before craft beer really took off in Sacramento, he says the industry itself was going in a direction he didn't like. "One of the reasons I'm probably not in the business anymore, I never thought there would be any way people would pay $6.00 or $7.00 for a pint of beer," he laments. "When we opened, we were charging $1.75 a pint."

Brown sold to longtime friend Glynn Phillips. "I ran the Marin Brewing Company for seven years, and before that I ran the Great Basin Brewing Company in Sparks, Nevada, for four years. So going on twenty-five years of beer business," Phillips explains.

At the time of the sale, the Sacramento craft beer scene was nearly nonexistent. Phillips says there were just seven breweries in the region, and most of those are now gone. But after a decade of ownership, Phillips would have to steer the Rubicon as the number of breweries and the amount of competition exploded.

"You really have to stay ahead of the game. We saw the [craft beer] wave coming and decided to start really developing our outside business," Phillips says. He ushered in change at the Rubicon, expanding its beer menu to keep at least ten beers on tap to keep up with consumer demand for variety. "I opened a production brewery in 2013, and we grew the outside business by like 400 percent."

But now, Phillips says it might have all been too much too fast. In August 2017, just three months short of the Rubicon's thirtieth anniversary, Phillips announced via Facebook that Sacramento's oldest brewery would close its doors.

I had spoken with Phillips in the early summer of 2017, and we had discussed his plans for the Rubicon's thirtieth-anniversary celebrations. Just two months later, we spoke again to discuss the brewpub's closure. "To

say it was sudden, yeah, sort of. Did I see it coming? Yeah, sort of. When you own your own business and you're trying to make things work well, what you see is the ability to produce. And so I always held out hope that it was all going to work."

He says increased competition for tap and shelf space, not to mention the growing number of brewery options, took a toll. But more so, the financial requirements of trying to produce beer at such a high volume were just too much to sustain. While he says it didn't work out, he will look back at his time at the Rubicon fondly.

"The joy that I have taken from running this business for as long as I have, which would be close to thirteen years, is that I've been able to provide a good living for a lot of people," Phillips says. "I have no regrets…over the decisions that I've made or the way that I've acted or anything that I've done because all along I've tried to make the best decisions for our business and the people that work here."

Phillips says he will get out of the beer game, at least for now. Even as he does, like Ed Brown before him, he will leave a lasting legacy in the region. Phillips created the Northern California Brewers Guild, which got so large that it now has an offshoot, the Sacramento Area Brewers Guild. He also started the annual Brewfest at Raley Field.

The fate of the Rubicon was unsettled for months, but now with a new Spanish-themed brewpub set to open in the Capitol Avenue location sometime in 2018, it seems unlikely the Rubicon will return.

"It's sad to see a great brewer like Rubicon go, but it's a little bit of the reality of the marketplace today that it is competitive and increasingly more so," says Sierra Nevada's Ken Grossman. "The taste of the consumer has changed dramatically. What was a popular style…that style has evolved. IPAs and pale ales and wheat beers, all the original craft styles have all gone to different tangents."

Even with the Rubicon gone, the contributions it made in paving the way not only for the craft beer boom in the Sacramento region over the last ten years but the craft beer industry as a whole should not be forgotten. After all, Deschutes, Bear Republic and Auburn Alehouse can trace their roots back here.

"In 1996, I went through the Brewer's Guild and they do internships, and I had already been a fan of the Rubicon and I knew it was a small hands-on brewery, and I wanted to get my feet wet doing pretty much everything you could do," says Auburn Alehouse owner Brian Ford, who followed up the internship by working at the Rubicon for a few months before opening

his own brewery. "The Rubicon was basically where I cut my teeth on professionally brewing."

"Those guys are such good friends of ours and have been for twenty years. It's definitely sad to see them go," he adds.

Rubicon's IPA also inspired a generation of beer makers, including those at breweries like Russian River.

And above all else, Ed Brown, Glynn Phillips and the Rubicon played a significant role in the community and were a cornerstone in Sacramento for nearly thirty years.

"I know a lot of personal relationships were founded here and grounded here. And probably quite a few kids were created after their visit to the Rubicon," Brown jokes. Then he reflects and says, "It was a lot of fun. I guess I was, we were, a pioneer."

THE NEW WAVE

Rubicon's opening was followed by the opening of several other breweries and brewpubs in the Sacramento region. Sudwerk Brewery opened in Davis shortly after the Rubicon. River City Brewing, Hoppy Brewing, Sacramento Brewing Company and Brew It Up opened in Sacramento. There would be others—some successful, some not so much—over the next twenty-five years, but there were really never more than a handful of breweries in the region at any given time.

So how did a region that was late to the craft beer party and seemingly a dead zone for breweries become one of the fastest-growing beer-making regions in the entire country? The answer may lie in the region's pioneering spirit in the farm-to-fork movement. The region's consumers were demanding that their food be fresh, locally grown and of high quality. So it was only a matter of time before that same demand was put on beer.

"Farm-to-fork came first. I think the restaurant boom happened right around 2009; things were really starting to take off," says Robertson. "And then craft beer, five years later, rode that momentum. I think a lot of foodies were also ready for beer as well."

"There's a giant demand for not only locally made product but very fresh product and product you can depend on and where when you walk into a place you see the owner and/or you spend money somewhere and you're talking to that bartender, you know that that bartender lives and works in the area that you live and work," says former Rubicon owner Glynn Phillips.

Fresh and local. Phillips points out that even the definition of "local" has changed during his twenty-five years in the industry. "When I first started selling beer, local was West Coast area," he says. "Then it was California. Then it was Bay Area. And now it's Sacramento and gotten down to regions of Sacramento."

Beer Pairing: In the next section, we'll focus on the three breweries that really shaped where the craft beer industry was headed in this region. Let's crack open a Track 7 Panic IPA and get started.

BLAST FROM THE PAST SHAPING THE FUTURE

If 2009 was the boom year for farm-to-fork restaurants, then 2011 was the boom year for craft beer in the Sacramento region. A handful of new breweries opened, but the one that gained the most attention early on was the one with the name that had been synonymous with Sacramento beer a century earlier: Ruhstaller.

Something you quickly learn about the group that started Ruhstaller Brewing Company is its passion for history. Talk to any member of the Ruhstaller Brewing Company contingent, and the first thing he will talk about is not the beer but the history it honors.

"Sacramento was a beer town; it's still a beer town. We were the beer capital of the West Coast, we had the largest hop-growing region in the world," says Jan-Erik (better known as JE) Paino. "We were shipping hops back to Europe, and a couple things hit us. Number 1, no one knew about that history."

Paino and his then partners are real estate developers by trade. It was when they were restoring the Citizen Hotel in downtown Sacramento that

Ruhstaller logo featuring the stencil of Frank Ruhstaller. *Ruhstaller Brewing Company.*

the idea of starting a brewery began to form. While the Citizen is steeped in its own history, it was a building a block or so away that caught the attention of the soon-to-be beer makers.

"I walked by this building all the time. I didn't really know much about it. I knew it was well built, then I learned it was built in the 1890s and it had an elevator; back in that time that was a really tall building. And then it had a guy's name on it, the Ruhstaller Building."

Around that same time, Paino was introduced to Ed Carroll's *Sacramento Breweries*, and his fascination with Frank Ruhstaller and the early beer brewers was born.

"This guy Ruhstaller was kind of right in the center of it all. He was the premier brewer of that era. Here was a person who had come here and seen opportunity and made the most of it. And that we felt like was a story worth telling," says Paino. "He's a great inspiration for me personally. I can somewhat relate to this young guy coming here, not having a lot and working his way up."

Out of the gate, the company made two big decisions. First, the brand would be used to capture the essence of Sacramento's brewing legacy, from the beers' names, to the classic design and etched glass, to the burlap hop sacks wrapped around the bottlenecks. Second, the beer would capitalize on the region's farm-to-fork movement, which meant using locally sourced ingredients as often as possible.

"I think that was something we learned with the Citizen and Grange, and we sort of made that a challenge to ourselves to see if it can be done. We understood that ingredients matter when it came to making stuff."

While that's a noble goal, there was just one big problem: no one in the group knew how to make beer.

To help solve that problem, Paino turned to just about the best source you could find—also the person who perhaps has the longest title you'll find in this book—Anheuser-Busch Endowed Professor of Malting and Brewing Sciences and current head of the brewing program Charles Bamforth, PhD, DSc.

"I joked that Charlie gave me a couple of books, all written by him; a couple of them were science books and a couple were history books. I loved the history books, but I didn't understand a word of the science books," laughs Paino. "So he put us in touch with some guys who knew about brewing, and that's kind of how we started."

One of those guys was Peter Hoey. Hoey, well known in the industry from his time as a brewer at Sacramento Brewing Company, had recently closed his Odonata Brewing and was pursing consulting work.

Cans of Ruhstaller beer, including its flagship, Gilt Edge Lager. *Ruhstaller Brewing Company.*

"I helped Sutter Buttes Brewery in Yuba City, which is still open and going. I helped them get up and producing and establish a lot of standard operating procedures and recipes," says Hoey. "I did something very similar for Ruhstaller."

Hoey helped bring Ruhstaller from concept to production, developing the recipes for Ruhstaller's red ale, the Captain; its black IPA, 1881; and what Ruhstaller hoped would be its flagship beer, Gilt Edge Lager. And he did it all using Ruhstaller's commitment to local ingredients.

"That was his mandate when we were kind of doing the early formulation of beers, recipes and ingredient sourcing was, 'This is core to Ruhstaller's values, and we want to use as much locally produced ingredients as we possibly can,'" Hoey explains.

"We found a farmer, really the only hop grower in California, in Lake County," explains Paino. "We also found some malt, barley that was grown in California but malted out of state."

Hoey only stayed with Ruhstaller for a short time, but the beers he helped create would help the company find quick success.

"They had a decent beer and a really good story and a good sort of roadmap of where they wanted to go and where Sacramento kind of needed to go," says former *Sacramento Bee* beer reporter Blair Robertson. He says at the time Ruhstaller was easily the hottest brewery in town.

Paino recalls selling around a dozen cases of Ruhstaller beer to Corti Brothers market around Christmas 2011 and receiving a call just a week or

Left: Original UC Davis Brewery, constructed in 1958. *Gregory Urquiaga, UC Davis.*

Below: Ruhstaller owner JE Paino at the hop yard in Dixon. *Author's collection.*

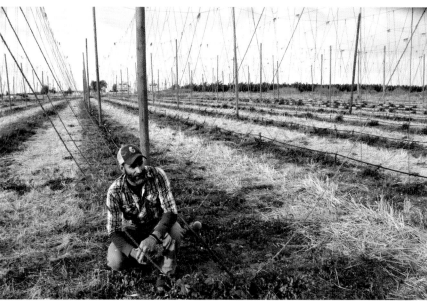

Left: A flight from Blue Note Brewery located just blocks from the area's first brewpub, which opened in Woodland in 1986. *Author's collection.*

Below: The YOLO Brewing Company logo reflecting in a pint of beer. *Author's collection.*

Oak Park Brewing Company in Sacramento. *Oak Park Brewing Company.*

Kyle Blaikie pumping up the Sloppy Moose Running Club members before their run. *Author's collection.*

Students stretching as part of yoga offered at Big Stump Brewing Company. *Author's collection.*

A flight of ten different beers at Auburn's Crooked Lane Brewery. *Author's collection.*

Inside the taproom of Crooked Lane Brewing Company in Auburn. *Author's collection.*

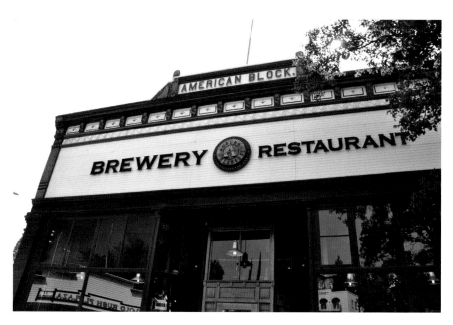

Outside the Auburn Alehouse, one of the many breweries with ties to the Rubicon. *Author's collection.*

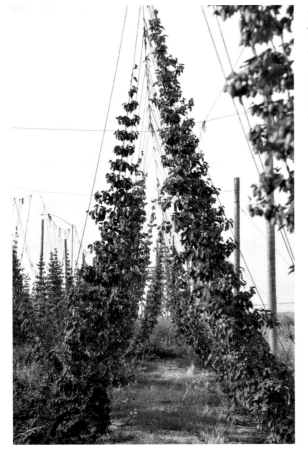

Above: Hops on the vine just before harvesting at the Ruhstaller farm in Dixon. *Author's collection.*

Left: Hops growing in 2017 still using the same trellis system developed in 1884. *Author's collection.*

You never know what sort of characters you'll find on the Sac Brew Bike. *Sac Brew Bike.*

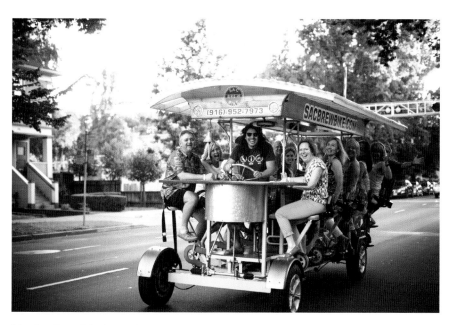

The Sac Brew Bike is a pedal-power party. *Sac Brew Bike.*

Left to right: Sean Mohsenzadegan, Michelle Mohsenzadegan and Andrew Mohsenzadegan from Flatland Brewing. *Flatland Brewing Company.*

Mraz Brewing Company uses the sale of a different beer each month to support its charity of the month. *Mraz Brewing Company.*

The Craft Creamery's Crooked Lane Pupup Baltic Porter with English Toffee and Maldon Salt. *The Craft Creamery.*

The Craft Creamery's Mraz Saison Je' with Blackberries. *The Craft Creamery.*

The logo for the Sacramento Beer Enthusiasts, one of the largest beer groups on Facebook. *Russell Kay.*

This mural represents the world changers honored by Sactown Union's Revolutionaries Series of beers. *Author's collection.*

Above: Inside Claimstake Brewing Company's Rancho Cordova taproom. *Author's collection.*

Left: A beer and coaster at Claimstake. *Author's collection.*

The taproom for New Glory Brewing Company filling up on a Sunday afternoon. *Author's collection.*

A flight of beers at Sacramento's Fountainhead Brewing Company. *Author's collection.*

Left: Customers dropping bags of hops, barley and malt into the kettles at YOLO Brewing during a personal brewing session. *Author's collection.*

Below: A tap handle maker display at the California Craft Beer Summit at the Sacramento Convention Center. *Author's collection.*

Examples of tip trays used by the Buffalo Brewing Company. *Steve Abbott Collection.*

Inside Oak Park Brewing Company, where the style is described as "steampunkish." *Oak Park Brewing Company.*

Above: The new brew house at New Helvetia Brewing Company. *New Helvetia Brewing Company.*

Left: A sampler tray of beer from Elk Grove's Tilted Mash. *Tilted Mash.*

Left: Four-year anniversary glasses served at Bike Dog's original West Sacramento location. *Author's collection.*

Below: The owners of Sactown Union say it took years to develop their business plan. *Author's collection.*

two later asking for more. He initially thought maybe there was a problem, but the store said they had simply sold out that quickly.

That partnership with Corti Brothers would lead to another turning point both for Paino and Ruhstaller. Paino describes a meeting with Darrel Corti where he challenged Paino to make his beer using locally grown hops. It's a challenge Paino would accept, starting a hop yard first in Winters and now Dixon. We'll explore Ruhstaller's hop farming more closely in a later chapter.

While the Ruhstaller team was farming, what it wasn't doing was brewing—at least not in its own brewery. Paino and team decided to mitigate some of the financial risk of getting into the beer business by foregoing a brewery and instead contract brewing, something they still do today.

"We had a little test brewery downtown at 630 K, but there was a lot of excess capacity at existing breweries at the time," Paino explains. "It was common; it's not so common now, but it's always been pretty common where breweries share facilities."

"I think a lot of people thought that was a pretty good business plan, stay lean and mean for a while, don't get heavily into debt," says Robertson. "But as the Sacramento market started to blossom, it became apparent we wanted little warehouse-style breweries to go hang out, and Ruhstaller didn't have that."

Hoey, who contract brewed while operating Odonata, agrees. "You're at a beer fest, and you're pouring beer and [beer drinkers are] like, 'Where's your brewery? Can I come visit?' And you're like, 'Well, I have this other brewery brew it for me, but I do all the brewing and they're my recipes.' So really it's too long of an explanation. They just want to know, 'Can I come to your place and have a beer.'"

That lack of a brick-and-mortar brewery has added to the debate about whether Ruhstaller is truly making a "Sacramento beer." Is the beer defined by its ingredients or where those ingredients are put together?

Paino uses examples of wine, cheese and even fruit that are defined as local based on where the ingredients come from, not where they are packed, and questions why beer isn't held to that same standard. He concedes that hops, barley and other beer ingredients can only be grown in certain locations, which would obviously limit the number of cities that could claim "local beer."

Hoey compares the idea of local beer to another popular craft drink: "I like to liken it to coffee because everyone accepts that a coffee roaster is a local roaster if they have a shop in town."

Robertson says Ruhstaller stumbled a bit in other areas as well, by not making an IPA out of the gate and not hiring a full-time brewer whom people could get to know. Now, he says, one of the pioneers of this craft beer boom gets a little lost in the crowd: "It's a little sad because they really could be the Sacramento standard, but they just kind of missed the mark."

Whatever your opinion about Ruhstaller or its definition of a Sacramento beer, one thing can't be disputed: like Frank Ruhstaller himself, Paino and his team played an integral part in the history of Sacramento beer.

"They are important because in the early stages in what had the makings of a Sacramento boom, Ruhstaller pulled it all together and had a great vision for what Sacramento was and what it could be again," says Robertson. "I think the way JE Paino sort of painted the picture of Sacramento beer, the new chapter, I think it might have inspired a lot of potential brewers and brewery owners to buy into it."

Paino says it's important to do the Ruhstaller name proud. "We've always said, we don't want to fail because we made a bad decision or made bad beer, and if that means we're going to grow a little slower and miss some opportunities, that's OK. This is a long-term thing; it's not blow it up and cash out in two years and get bought. That's not what we are trying to do."

Getting on Track

Ruhstaller signaled the beginning of the new era in beer making in the Sacramento region, but it was not the brewing company that would serve as the prototype for the style of brewery that would become commonplace throughout the region. For that, you had to look at a small industrial area of Sacramento's Curtis Park.

"Track 7 really was the first brewery of that wave," says New Helvetia owner Dave Gull. "Ruhstaller launched a brand, but they didn't launch a brewery. Track 7 launched a brewery."

"Starting, our goal was to be Sacramento's regional brewery and really focus on Sacramento and make sure we owned our home market," says Track 7 co-founder Geoff Scott. "We wanted to be the brewery that was kind of synonymous with Sacramento."

The "we" is Geoff and his brewing partner and college buddy Ryan Graham. The two were home brewers, and despite living in opposite ends

Track 7 opened this production facility and taproom in Natomas in 2015. *Author's collection.*

of the state, they stayed close, often driving to each other's homes, kegs of home-brew in tow, to host beer parties.

"One day after one of the beer parties, we decided to talk about it, and at that point we developed the business plan and started the motion of Track 7," Scott says. "We did market surveys and looked at profit margins as far as like pricing for beer. We had a pretty in-depth business plan. Ryan did a great job on it."

But Graham also admits that at the time, Sacramento was in a weird place with craft beer. He says they ran demographic numbers showing that when it came to local beer, the area was underrepresented. But at the same time, several local breweries were struggling to stay afloat.

"Sacramento Brewing Company had gone out of business at that point, Beermann's had gone out of business, Brew It Up was while we were in business planning went out of business…and so it was kind of counterintuitive in a certain sense that even though [Sacramento] was underrepresented, the breweries that were here weren't being really supported," Graham says.

Still, the duo believed in their plan, and after searching in Midtown and the Arden area, Scott and Graham opened a brewery and taproom split between two warehouse spaces in Sacramento's Curtis Park. It was an

industrial area most people would never have had a reason to visit. "When I proposed the location at Curtis Park, everyone, including my wife, said, 'Are you crazy?'"

But Graham believed the location could work, partly because he'd seen a similar situation work in Southern California. But he admits the main motivation for selecting the location was the rent was affordable, and for a startup brewery, that was most important. "I wish that I could say I scoured Sacramento's area looking for the right mix of residential demographics and that I happened to be right. The reality, however, is that's one of those times where you say you need a little bit of luck and that's what happened."

With a location secured, Track 7 opened its doors on New Year's Eve 2011. And the duo would ring in the New Year in a truly unforgettable fashion.

"When we rolled up our doors, rolled them up for the first time, there were forty to fifty people sitting in line, and we were super surprised and excited, and it's kind of just snowballed from there," Scott recalls.

"It was an interesting experience. It was something we were most certainly ill equipped for. We didn't run any soft opening because, again, we didn't think anyone would care," Graham recalls. "At that point, we didn't have dishwashers; we had to hand wash every glass that went through. It just was an interesting experience. We'll never experience something like that again. It was just completely unanticipated."

Track 7 took off behind beers like Panic IPA, Left Eye Right Eye Double IPA and the Nukin' Futz Imperial Peanut Butter Chocolate Cream Porter. Now this little industrial complex in an out-of-the-way area was a destination location.

"That was one thing we talked about in the business plan was like, location is important, but ultimately if you have good beer, the beer community is going to come find you. Because that's what they ultimately want: high-quality beer, and they're willing to travel for it or go searching for it," Scott says. "It's one great thing about where we're at: the people of Curtis Park and Land Park and the surrounding neighborhoods all kind of embrace us. We're kind of their local watering hole, they come, they walk there, they ride their bikes, they bring their dogs, they just come and hang out."

That support was something the brewing community immediately noticed.

"I was there that first opening day, and there was a line out the door," says Gull. At that time, he was already in the construction stage of opening New Helvetia, and Track 7's success helped validate his own brewery plans. "OK, these guys did it, they opened a real brewery here, they're actually

nearby in my neighborhood and there's a line out the door. That's pretty frickin' awesome."

Track 7's popularity changed the team's plans pretty quickly. Scott and Graham had initially planned to only have their taproom open on weekends, each taking every other weekend. Keep in mind Graham was still living in Southern California. Six months in, they realized they needed a full-time position, so Graham moved north in August 2012. By August 2013, Scott and his wife were working at Track 7 full time. Meanwhile, beer production was increasing and so was demand. In 2015, Track 7 made a huge move.

"We started self-distributing, and we built up a pretty good following doing that. Then we went into talks with Markstein Beverage. They were a big supporter and a reason why we needed to grow because they did a great job distributing our beer. They were getting to accounts we couldn't get into, and they were getting chain stores set up," says Scott. "They were like, 'Hey, this thing could really take off with you guys. We're going to need more beer.'"

The Curtis Park location was maxed out in terms of production, so the search began for a larger production facility. That search took the team to Natomas, where they not only found a suitable thirty-six-thousand-square-foot location but were also the only brewery in the area. With the new facility online, Track 7 has been able to up its production from around 250 barrels in 2012 to somewhere between 18,000 and 20,000 in 2017.

Track 7 distributes around California but isn't looking to leave the state. The focus, as it always has been, is on the Sacramento region. Scott and Graham may even have more plans to expand in the area. In the summer of 2017, the brewery announced it was considering a third taproom in Roseville.

Former *Bee* writer Blair Robertson points to Track 7's early success as setting the stage for the craft beer boom the region is enjoying today. "I think if a place like Track 7 was making bad beer, I think maybe this growth would have stalled. But some of these early places were making really good beer."

Look around at any city in the region and you'll see some of Track 7's influence. Whether you're in Rancho Cordova, Auburn, West Sacramento or Elk Grove, you'll find a brewery or breweries that are housed in an out-of-the-way industrial area.

"It certainly helped to see that they were making it happen and doing it and seeing people really connect with that," says Bike Dog co-founder A.J. Tendick. "It certainly steered us in terms of, you could see them being

next to a neighborhood, how well that worked, so that was definitely on our minds in terms of location."

Titled Mash co-founder Jonathan Martinez shares a similar story: "When we first started, we saw how Track 7 started in Curtis Park; they had their two little suites together. It was like, 'Wow, we can totally do something like that.'"

Track 7 didn't invent the warehouse brewery model, but certainly it can be credited with bringing it to the region. "We were pioneering a new business model in the Sacramento marketplace that hadn't existed before here," Graham says.

Scott adds, "We got the ball rolling on it, and people from that point on were just like, 'Hey, this is possible.' You can start a brewery in a warehouse with not a tremendous amount of investment and you can really focus on what you're passionate about and provide good beer to people in the city of Sacramento."

KNEE DEEP IN DISTRIBUTION

While breweries like Ruhstaller and Track 7 were laying the groundwork for the craft beer boom in Sacramento, another brewery in the foothills was on its way to becoming known not only here but around the country and the world.

"In 2009, I was developing the recipes and business plan out of my garage in Reno, Nevada," says Knee Deep founder Jeremy Warren. "I originally founded that company in 2010. The first business license was in Sparks, Nevada." That's right. Auburn's best-known brewery actually started in a garage…in Nevada. But big changes would come quickly.

"In late 2010, early 2011 if I remember correctly, that's when Gerald Moore bought out some of my previous business partners and took over as managing member of Knee Deep Brewing Company LLC," Warren recalls.

"My dad actually came out of retirement and wanted to get into the wine industry," says Andrew Moore, Knee Deep's sales and marketing manager. "He went out and didn't have any interest in being a brewer per se, just kind of wanted to have control of the business."

The partnership of Jeremy Warren and Jerry Moore would prove to be an effective one. Moore's business background perfectly complemented Warren's background as an award-winning home brewer. But Knee Deep

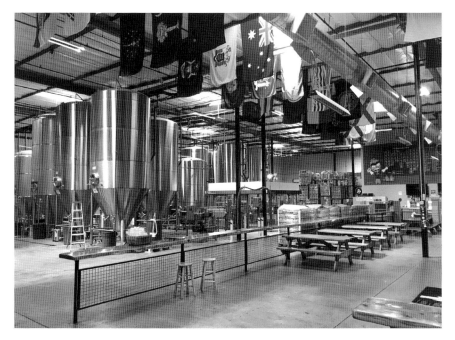

Inside Knee Deep Brewing Company at its current location in Auburn. *Knee Deep Brewing Company.*

was certainly not an overnight success. It took a couple of relocations and a brewery discovering its identity before Knee Deep really took off. But the story of this brewery starts with a father and son.

"Home brewing was a way for me to connect with my father, because he was always into craft beer," says Warren. "Believe it or not, there was a time I really wasn't into craft beer, and that really gave me an opportunity to bond with my dad."

Warren says he received his first home brewing kit from his ex-wife for Christmas. It didn't really come with directions, so Warren just winged it on his first batch. "I just remember brewing this beer in my garage, not knowing when to throw the hops in, and I was like, 'You know what? I'm just going to throw them in at this point.' It was the middle of winter, and when the brew was done, I was like, 'How do I cool this down?' So I just left it in the garage overnight because it was cold out. Believe it or not, that batch was really good. But for about three months after that, I couldn't make another good beer."

That's when Warren buckled down and started studying the science of brewing beer. He eventually entered a Reno-area home brewing

competition, where he took home first prize not only in the people's choice but in the judging as well. His prize: to attend Beer Camp at Sierra Nevada Brewing Company.

"When I was driving home from Chico, I was determined that I'm going to get into this industry one way or another." That way would include being laid off from the job he had taken out of college. "I told my wife at the time, 'Hey, I have good news and bad news.' She goes, 'What's the bad news?' I go, 'I lost my job today.' And she goes, 'What the hell can the good news be?' And I'm going, 'I'm getting in the beer business!' And she goes, 'No, you're not.' And so we were divorced about three or four months later, and then within three months of that, I had my first business license for Knee Deep Brewing."

It wasn't easy though. Warren says he started with just $15,000. He used half of that to buy kegs, the other half for materials and to contract brew.

"In the beginning stages of Knee Deep, I was struggling, really struggling," Warren says. "But then when Jerry came in, he really put us on the right path on the business standpoint."

Andrew Moore says for his dad, it was almost just something to do. "He had the business background, owned two companies and sold them off. He wanted to essentially, not really get his hands dirty but wanted to be on the management side."

At the time, Warren was coming up with the recipes, but someone else was doing the brewing, and both he and the Moores agreed that contract brewing was not going to sustain their business. "We had a lot of issues with the contract brewing, a lot of sucky beers," says Moore. "When you contract brew, you kind of lose control of the quality in a way because you're not the one that is babying your own brew system."

Warren agrees: "When we were contract brewing, we were having some challenges. We kind of determined that if Knee Deep is going to be successful and make it, Knee Deep needs its own brewery."

The original Beermann's had closed a few years earlier, so the now empty brewery made an ideal location for the Knee Deep team. By May 2011, Knee Deep was for the first time brewing its own beer. It would eventually phase out contract brewing altogether, and for the first time since getting that business license, Knee Deep was running independently and starting to gain traction.

"It seemed like just under a year in our Lincoln facility was when we really started making a push. Our bombers were selling really well," Moore says. "We sold in six states almost right off the bat."

While other breweries were beginning to open taprooms, Knee Deep was hosting "Loading Dock Fridays," where it would sell bottles and fill growlers. But the real focus was on distribution. Knee Deep was pursuing and continues to pursue a business model that no other Sacramento-area brewery has been able to match.

"Jerry Moore, really good on the business side, was really able to connect with a lot of the distributors and definitely knows how to sell product," Warren says. "I'd say in the beginning it really wasn't our focus, but then it just became what it is."

"When we first opened the brewery, my dad didn't even really want to open a taproom; he just wanted to make beer and sell it to distributors." Andrew Moore adds, "We wanted to be known as one of the only brewers in the Sacramento area that sold outside of the home market, the home territory."

The cold box at the current Knee Deep facility in Auburn. *Knee Deep Brewing Company.*

But even at that point, Warren says, Knee Deep still really lacked identity. That would change when he asked his partner about brewing a special beer for competition. "In 2012, my dad and I had been going to the Bistro Double IPA Fest for ten-plus years, and I asked my business partner, 'Do you have a problem if I develop a double IPA for this competition?' So that's when we developed the Hoptologist for this competition."

It was a decision that probably changed the course of history for the brewery. Hoptologist beat out legendary California Double IPA Pliny the Elder to take home the Best of Show. It created a buzz about Knee Deep that maybe wasn't there before, and it would define the brewery and Jeremy Warren's brewing style going forward.

Warren says, "That's the one medal, the one competition. That competition defined Knee Deep. Before that, I wasn't allowed to brew any IPAs. We had one; I wasn't allowed to do any other ones. I was being told to brew these more classical styles. And then when we won that competition and my previous business partners saw the benefit of that, that's when he kind of turned me loose and started letting me do the styles I'm really good at."

From that point on, Knee Deep would be known for its hop-forward IPAs. Warren created signature beers to complement Hoptologist, including Simtra, Citra, Hop Trio, Tanilla and Breaking Bud.

With an identity in tow, the brewery moved to its current home in Auburn. The new facility included Knee Deep's first taproom and a larger production facility. In 2016, Knee Deep produced just over fifteen thousand barrels of beer. In 2017, that number was expected to cross twenty thousand.

Despite taproom success, distribution remains the key to the business plan. As of the summer of 2017, Knee Deep was being distributed in thirty states and six countries. Moore says at least two more countries would be added to that list by the time you read this book. "We want everyone in the world to try our beer. So we want to get it out to everybody."

"People always ask me, 'How did you guys grow so quickly? How did you guys get to where you're at?'" says Warren. "From a brewer's perspective, I honestly just make beer that I like to drink."

Also by the time you read this, Knee Deep is expected to have added its own canning line, allowing the brewery to do more one-off brews. The one thing Knee Deep doesn't have any more is Jeremy Warren. The man who started the company in his garage left in 2015 due to some creative differences.

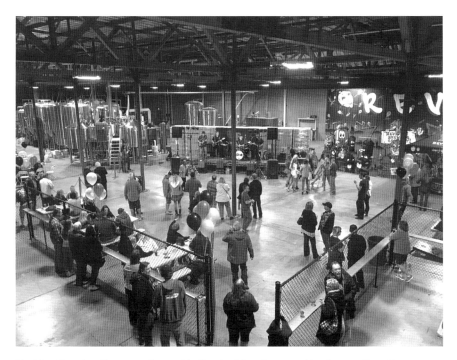

Revision Brewing Company, located in Sparks, Nevada, owned by former Knee Deep founder Jeremy Warren. *Revision Brewing Company.*

Warren wouldn't be down for long. He started a new brewery called Revision, based out of Sparks, Nevada, where Knee Deep was also born. And like Knee Deep, Revision has an eye for distribution, already having signed deals before Warren had even brewed the first Revision beer. In less than a year of operation, Revision can already be found in stores in eleven states and Australia.

"Every lesson I learned I apply here, all the way from how to work with your employees, the business models, you know, managing the finances. To me, I feel my most important job is just maintaining the right company culture." Warren also makes it clear he holds no ill will toward his former partner Jeff Moore: "I wouldn't be able to do what I'm doing today on the business side if I never was his partner. He is really good at the business, and I did learn a lot."

CHAPTER 5
CLUSTERS OF CRAFT

I'm not planning on going into the history of each and every brewery; that would take forever. So let me give you some quick basics as we move on.

In all, six new breweries opened their doors in 2011 in the Sacramento region. That was the most that opened in one year until 2015. That first wave—led by Ruhstaller, Track 7 and Knee Deep, along with Berryessa Brewing Company and Loomis Basin—set the standard for craft beer in the region.

Over the next few years, dozens more breweries opened. Many of these opened in geographic clusters. Head to New Glory and you'll find Device around the corner. In Elk Grove, Tilted Mash and Flatland Brewing are less than two miles apart, with the recently opened Waterman Brewing Company a little farther away than that. Or in Davis, you'll find Sudwerk, Three Mile Brewing and the recently opened Super Owl Brewing Company.

In this next section, I want to focus on two areas that have probably seen some of the biggest benefits from these clusters: the city of West Sacramento and the city of Auburn.

Beer Pairing: I'm going to recommend two beers here. First you have to go with the Bike Dog staple San Dog IPA. And for the second, Moonraker's Yojo…if you can get your hands on it.

INDUSTRIAL DESTINATION

The brewery-in-an-industrial-area model used by Track 7 was new to Sacramento, but it wasn't new to craft beer. In areas like San Diego, Portland and other craft beer meccas, this is the standard.

"I borrowed bits and pieces from [brewery models] that I'd seen along the way and experienced along the way," says Track 7's Ryan Graham. "In particular, in the Inland Empire in Southern California, I had the good fortune of watching Hangar 24 grow up very much the same way we did."

It's the success of this model that explains why it's being re-created again and again and why cities are most often welcoming these breweries with open arms. "You see it revitalize a lot of neighborhoods when a brewery goes in. Sometimes they'll go into industrial parks or into cheaper areas of town, and you'll see that whole area reinvent itself around the brewery," says Leia Ostermann, managing director for the California Craft Brewers Association. "West Sac is a good example—that strip of YOLO, Bike Dog, Jackrabbit. No one went over there ever, and now it's a popular destination."

Best known for Raley Field, its strip of motels and Ikea, West Sacramento is often considered the little brother to the capital city across the river. It has a population about a tenth the size of Sacramento (fifty-three thousand compared to nearly half a million, according to 2016 U.S. census numbers). It doesn't have a central downtown or public transportation, but it does have a major port.

The Port of West Sacramento is home to huge silos and the even bigger barges that travel up and down the deep-water channel. But these days, the port area is also home to something else: the city's three craft breweries.

"West Sacramento did not set out to be an important center of craft brewing a decade ago. That wasn't part of our economic development strategy at all," says West Sacramento mayor Christopher Cabaldon. "It's an exaggeration, but not much, to say that there's very few places in West Sac where you're not within two thousand feet of local craft beer."

Cabaldon became the city's first mayor directly elected by voters in 2004. He prides himself on having an open and progressive style, especially when it comes to new business. This was most certainly the case when Bike Dog Brewing Company first approached the city about setting up shop in the port area.

"We knew and could tell that West Sac was sort of ready for this. So it was kind of a bunch of things. One, it was an open market. Two, the council and city staff were excited about this sort of thing," says Bike Dog co-founder

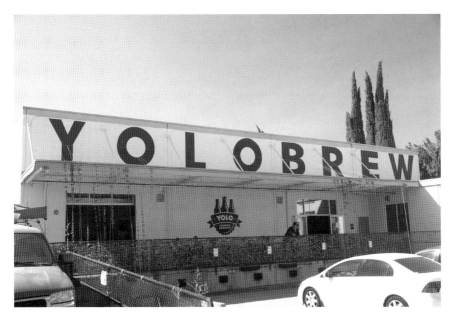

West Sacramento's YOLO Brewing Company. *Author's collection.*

A.J. Tendick. "If you go to Sacramento and something doesn't go by the book, they just tell you no. Whereas West Sac, you come in and they say, 'No…but let's work on it.'"

Rubicon was already in the process of setting up its production facility at the time, but what Bike Dog needed was the city to change laws that restricted the manufacture and sale of beer at the same location.

"The question we asked ourselves [was], 'What's the worst thing that could happen if someone started selling beer in the same place where they were producing beer?'" Mayor Cabaldon says instead of spending years on research to determine that answer, the city decided to let Bike Dog open and see what would happen. "The worst-case scenarios were all things we could deal with. So we said, go ahead and do it. We'll issue the permits, we'll change the laws later."

It can't be stated enough what a change this would lead to for the city. Bike Dog would open at the end of 2013, and with its iconic logo and focus on IPAs, it was an immediate hit.

Tendick recalls, "It was insane. We intentionally stocked with beer a little bit, as much as we could (we were super small), and we were onto our last four kegs of beer or something were tapped and half empty when nine o'clock rolled around and we shut the door. It was just insane."

The unmistakable Bike Dog logo greeting you at the entrance of the West Sacramento taproom. *Author's collection.*

YOLO and Jackrabbit would follow a year later (Jackrabbit wouldn't open a taproom until 2015), creating West Sacramento's "Beermuda Triangle." All three breweries are just a few blocks from one another, making it an easy one-stop-shop. "This area is becoming more and more of a destination," says YOLO CEO Rob McGormley. Rubicon also opened a taproom in its production facility located in the north end of the city.

Mayor Cabaldon credits the brewery boom for helping encourage the opening of craft beer–friendly restaurants like Brodericks, Flamming Grill and Burgers and Brew. He also says that success of The Barn and the fact that San Leandro–based Drakes Brewing Company has plans to take it over shows the impact craft beer is having in the region.

"There's no question that the beer scene in West Sacramento is having a significant effect on the overall marketability of the new neighborhoods and revitalized neighborhoods that we're creating in the community," he says.

Tendick and his partners wanted to open Bike Dog as a way to connect with people. What they ended up doing was connecting an entire community in a whole new way. Tendick says, "One business opening in Sacramento doesn't make a ripple. But we were able to do that, just sort of being the first and being in a small town and that kind of stuff. That certainly made us feel good and was exciting, and we were able to actually do what we wanted to do in terms of engage with the community and make it a better place and kind of give back in that way."

Bike Dog's success has led the brewery to expand back into Sacramento, where it has opened a second taproom. But Tendick says it isn't leaving West Sac behind; this move just helps them achieve the Bike Dog team's objective. "We're excited to be there and connect with more people. Because getting back to our core thing is connecting with folks, connecting with the community—just doing it in a community two miles over."

All In on Auburn

When the team behind Knee Deep decided to move to Auburn, competition was limited, with the only other game in the town the well-established Auburn Alehouse. It wouldn't stay that way for long.

"We were the second brewery to come into Auburn, and now there's four breweries here and, from what I hear, about to be a fifth," says Knee Deep's Andrew Moore.

Four, possibly five breweries in a town of around fourteen thousand people might seem like a lot, but it turns out it's exactly the right fit and has made Auburn a beer lover's destination.

In the past, Auburn was often seen as nothing more than a pit stop between San Francisco and Tahoe. While some might have viewed that as a negative, Brian Ford saw as it as an advantage when he opened the Auburn Alehouse in 2007.

"We knew we would be a stop along the way for folks traveling up from the Bay Area," says Ford. "So it's a good stopping point to get something to eat, grab some beer and grab some beer to go. It just made sense."

As mentioned earlier, Ford started brewing beer at the Rubicon in Sacramento as an intern in 1996. From there, he helped run and operate a brewery in Nevada City called Stone House. That led to another opportunity to start the Beermann's brewery in Lincoln (the same Beermann's where, coincidentally, Knee Deep would eventually brew). After five years of brewing there, Ford opened the Auburn Alehouse.

"Basically, Auburn needed a good restaurant and brewery," says Ford. "There had been a brewery some years before, and it was just a production facility. We opened a full brewpub model where we have a full restaurant and, of course, the operating brewery, and it was just a huge hit. Auburn needed something new. Our timing was pretty spot-on with that."

Like much of the Sacramento region, Auburn has a deep history of brewing that dates all the way back to the gold rush. The first brewery opened there shortly after the discovery of gold but only lasted maybe a year or two. The Kaiser Brewery then opened in 1856, and while it would change names and owners a few times, it stayed in operation for fifty-two years. Perhaps some of that success could be attributed to its location: it was located on a site a shot glass throw away from where the precious metal was being found. The brewery was so near numerous saloons that barrels of beer could be wheeled to the bars by hand.

Along the way, the Kaiser Brewery (later called the Auburn Brewery and then Broadway Brewery) won an award for its steam beer at the world's fair in St. Louis in 1904. The brewery closed for good in 1908, mostly attributed to the advancements in transportation, meaning beer could be easily brought to Auburn from other areas.[52]

"This area, like a lot of small mining towns, had little breweries to make sure the miners were well taken care of when they were done for the day," Ford says. "So we just brought back what was here in the early, formidable era of Auburn."

And brought it back in grand fashion. The brewpub offers up award-winning beer and good eats. That combination helped establish Auburn as a beer destination, and that notion was only furthered when Knee Deep moved into town.

"With Knee Deep coming in, that was kind of the trigger for a bunch of other breweries as well," Ford says.

Among those is Moonraker, a relative newcomer that is drawing attention from around the state. "I remember when Moonraker opened, I thought, 'Moonraker? What kind of name is that? Give them a few months and see if they're any good,'" says former *Sacramento Bee* reporter Blair Robertson. "And then somebody said, 'Have you been to Moonraker yet?' I said, 'Oh, they're doing a northeast hazy IPA; we'll give them a few months and see if that's any good.' And so by the time I got to Moonraker, they were just exploding. They were already famous before they had their first-year anniversary."

Karen and Dan Powell are the husband-and-wife team behind Moonraker. Like many would-be brewery owners, they started brewing at home. "We just started brewing on the weekends, and one thing led to another. That's actually how we met our head brewer, Zack, because he actually worked in the home-brew shop in Roseville," Karen explains.

Zack Frasher had himself been a home brewer and had been working in the industry. When the Powells approached him about becoming the lead brewer at Moonraker, he already had a very specific plan in mind.

"My husband said, 'What's your goal, what do you want to do?' And he [Zack] said, 'My goal is to make a New England–style beer and put it in a sixteen-ounce can.' And we were one of the first breweries, not only to make a New England–style beer up in Northern California, but to also put beer in a sixteen-ounce can." Powell says what was already popular on the East Coast would spread like wildfire here.

The beer is called Yojo, and people wait in line for hours to get it. Yojo helped Moonraker win three Ratebeer Awards in 2017, including Best

Inside Moonraker Brewing Company in Auburn. *Author's collection.*

New Beer, Best New Brewery in California and Ninth Best New Brewery Worldwide.[53] The accolades didn't stop there.

"We won those three awards for Ratebeer in January, and then two weeks later, we won the award for our Extremist, which is our triple IPA, at the Bistro [Triple IPA contest], where we beat out Pliny the Younger. It was just a little insane," admits Karen Powell.

In less than a year, Moonraker had garnered a reputation as one of the best breweries in the region. Its beers are highly sought after, and the limited releases only add to the mystique.

"Maybe this is one other thing that the Sacramento region needed. We needed the neighborhood spot, the badass spot and then we needed some celebrity—famous mystical things like Pliny the Younger, Pliny the Elder, and that's what Moonraker was doing," says Robertson.

All of that combines to make Moonraker a destination for beer lovers around the state. "Most of our [weekend] business comes from out of town, which is good for the local environment of Auburn because they're spending money here where they normally would not," Powell adds.

And that includes the other breweries in the region. Moonraker is basically across the street from Knee Deep, and both are down the street from another newcomer to the beer scene, Crooked Lane.

Unlike some of the other breweries that are tucked away in industrial warehouses, Crooked Lane is located right along Highway 49 in a can't-help-but-notice-it building that looks more like the Greek Parthenon than a brew house.

"We went through a lot of different locations before we settled on this one," says Crooked Lane co-owner Teresa Psuty. "We'd actually drive past this building, and it used to be just stark white giant columns out front, and we thought, 'That place is so gaudy. I don't even understand what that's for.'"

Maybe that's because the building has been used for a lot of things. Psuty says the building was originally a movie theater, then a karate studio and then a car dealership, which explains the pillars. "Turns out once we got inside and made a basic plan of what we can do here, we're like, 'Wow, this could really be something special, something different.'"

The beautiful tasting room is not the only thing that separates Crooked Lane from the rest; Psuty is also the master brewer. That means that along with Jennifer Talley at Auburn Alehouse, two of the city's four breweries have women in lead beer-making roles.

"It's something I appreciate, to be able to come into this role and put an example out there that you can be a totally successful brewer and be a woman," Psuty says. "It doesn't have anything to do with gender. It's more about enthusiasm, passion, attention to detail. I'm excited for the day when it's not such a big deal."

Ford agrees that while having female brewers might be unique for now, when it comes to the beer, you shouldn't be able to tell the difference. "Jennifer has been in the industry as long as I have, if not longer," says Ford. "So we're pretty much the old seasoned brewers. I don't think you can tell the difference between a guy brewing beer and a girl brewing beer."

The building notoriety of Auburn's breweries has turned the foothills community into a beer destination, making it truly a case of the rising tide lifting all ships.

"We love it that sometimes people will come up and go to one of these other breweries, and then they'll come to us and they'll be like, 'Oh wow, it's so comfortable here and you guys have great beer. We're so happy we came now. Now we're going to hang out here,'" Psuty adds. "You didn't know you were coming here, but now you're glad you did."

Knee Deep's Andrew Moore says the beer boom has changed the way people view the town altogether. "Auburn is such a great community, great outdoors community, a lot of history here," says Moore. "So with the taprooms coming into play, a lot of the other establishments that are popping up, you see a lot of people driving up here from all over the Northern California area just to come hang out for the day."

"I've been in the industry over twenty years," Ford adds. "So for me, it was that's kind of how I identified this area; I thought a brewery would do well in Auburn."

He was right, though it turns out it's actually four breweries that are doing well in Auburn.

CHAPTER 6
BREWING SUCCESS

While looking at the history of brewing in Sacramento and the more recent craft beer boom in the region, it's important to understand what it takes to run a brewery and keep it running. The beer is only part of the equation.

"[Running a brewery] is going to be like any other industry; you have to have a good business plan, good business sense, run your company well and have a good product," says local brewing legend and now Urban Roots Brewing & Smokehouse co-founder Peter Hoey.

Hoey would know. He's been part of the region's craft brew scene since 1998, when he took his first brewing job with Sacramento Brewing Company. Hoey helped Sacramento Brewing achieve great success. It would win several awards at prestigious events like the Great American Beer Festival and the World Beer Cup but couldn't survive the great recession. It's an example of good beer just not being enough to sustain a business.

"It wasn't the quality of their beer that was their detriment," says Track 7's Ryan Graham. "At a certain point in time, you stop running a brew house, and you start running a business. That's the challenge, I think; some of these people that have gone out of business and some of the brands that haven't quite made it, haven't kept the focus on running a successful business and the challenges that go along with that."

Ken Grossman, whose Sierra Nevada is valued at more than $1 billion, agrees. "It's a challenging business, and there are some that are going to survive long term and some that are going to be challenged. If you're not able to [meet that challenge], then there will be some casualties."

The Sacramento region is already seeing those casualties. In the summer of 2017 alone, Rubicon, American River Brewing Company and EDH Brewing Company closed their doors. Like with Sacramento Brewing Company, the problem isn't necessarily the quality of the beer. Breweries are dealing with more competition than ever in this region. And what may separate the surviving breweries from those that close will be just how well they are run as a business.

"You have to be a good neighborhood brewery that caters to people and makes them feel great and part of the family. Or make world-class award-winning beer that everybody wants to buy," says former *Sacramento Bee* reporter Blair Robertson. "If you're not one of those two things, you're going to have to go under."

Beer Pairing: If there's anyone who probably needs a drink, it's the guys and gals who own and operate a brewery. It's a lot of work, and it's even more work if you are going to operate a brewpub. So on that note, let's celebrate a hardworking brewpub owner and grab Auburn Alehouse's Great American Beer Festival Gold Medal–winning double red ale, Hop Donkey.

When a Plan Comes Together

The foundation of every brewery is the business plan. It is not typically a plan that comes together overnight. In fact, many of the brewery owners in the Sacramento region spend years coming up with their plans.

"It's a very complex multifaceted process because you need to be a brewer, a business owner, a designer and architect (or at least have input on all those trades)," says Hoey, who at the time of this writing was trying to launch his third brewery brand. "The most difficult part is managing all of those responsibilities at once."

Business planning is a process filled with enough numbers to make your head spin. "Your cost of doing business, your cost of living, the amount of money people spend here going out, the percentage of people here that are right in our target demo, how fast that group is growing" are just some of the numbers Sactown Union co-founder Quinn Gardner says you have to consider.

It's during this time when you make tough decisions, after learning the realities of your situation. Daniel Moffatt and Mark Bojescu, owners

of Fountainhead Brewing Company, initially thought they would open a brewpub. "We started doing some of the math and some of the business planning. The restaurant part fell out the more we learned about the permitting and all the stuff that was a real burden to planning it," Moffatt says. "It took us probably two to three years to open the doors."

Three years. That sounds like a long time, but it's nothing compared to the time it took for Gardner and partner Michael Baker. The Sactown Union duo says their planning process lasted seven and a half years and required them to relocate to Sacramento. "We waited until we were ready, until we had the location, we had the funds, we had the team, we had everything else behind us instead of just ambition and a plan," says Gardner.

Other items to figure out include location and whether they would brew themselves or contract brew, like Ruhstaller. "We didn't want to go out and commit to a lot of debt because maybe of our lack of experience on the brewing side," says JE Paino.

There are even basic decisions to be made, like what kind of beer to make. "We didn't want to be what everyone else was doing," says Jackrabbit Brewing Company co-founder Chris Powell. "We wanted to clear our own niche in the market." That niche includes beers like their English-style Pub Ale and Greybeard Old Ale, Order of the Rabbit (a Belgian-style Dubbel), a Golden Strong and, at any given time, a variety of saisons.

Add a restaurant into the mix, and now you are taking the challenge of planning and running a new business to the next level.

"The brewing business has always been very tough," says Grossman. "It's been very challenging particularly if you have a brewpub; you're running a number of businesses."

"Running a brewpub isn't easy," Auburn Alehouse's Brian Ford says. "We put the same energy into the food and service as we do the beer."

Despite the extra challenges, Ford stands by his decision to open a brewpub. "The brewpub model, I defend it; it's a great model," he says. "Being able to pair the food and the beer, being able to keep people in the seat a little longer, maybe sell them two beers, makes a lot of sense."

The four co-founders of Oak Park Brewing also took that challenge head-on. None had ever run a commercial brewery or a restaurant, yet they somehow ended up opening both. "None of us had it as our main goal," says co-founder Bonnie Peterson. "It just kind of evolved into that."

Brewery or brewpub, there is still the million-dollar question (and, in some cases, it's quite literally a million dollars) to be answered: where to find the money to own and operate a brewery.

SHOW ME THE MONEY

"The beer business is a very interesting world," says now-former Rubicon owner Glynn Phillips. "So here's my warning to anybody that wants to own a brewery: put together your business plan, and then double or triple it. Because it's a very cash-heavy, expensive business to get into."

"Brewing is an intensely, a hugely intensely…it's a very capital-intense endeavor. And not having appropriate funding is what will kill you," says Hoey. After Sacramento Brewing Company went out of business, he started his own brewery, called Odonata. It was a contract brand that only made saison-style beers. "That particular brewery was not cash-flow positive. Just in a sense that all of our bills were paid, but I didn't take a salary for two years, and we eventually ran out of money," Hoey explains. Odonata closed just a little more than a year after it opened. "We started with a shoestring budget; we were undercapitalized and basically learned really quickly that it takes a lot of money to grow a brand."

He says it's not just money to get your beer out there, it's also money to get your beer made. Hoey explains why you must be flush with cash, especially when you are starting out:

> If you're a new company, you likely don't have credit. You pay cash for your ingredients. You brew with them, and you have sellable beer in two to three weeks, depending on the styles of beer you're brewing. Let's say you have a wholesaler; you then sell it to the wholesaler, who then pays you thirty days later. So you're looking at nearly two months of production that you need the money for. And that's just one beer. Multiply that times however many beers you're selling.

Coming up with the money comes down to a couple options: find investors or go it alone. The latter is the approach Ken Anthony of Device and Mike Mraz of Mraz Brewing Company took to open their breweries.

"It's ideal; I just think it's unrealistic for most people," Anthony says. "Had we wanted to have a larger facility in a more convenient facility, we would have had to bring in outside money, you know, investors, and give up equity. Not that there's anything wrong with doing it that way, but there certainly can be challenges with that as well."

"You see a lot of breweries, they do the big warehouse, usually some investors or a big bank loan or whatever so they can start nice and big," says Lauren Zehnder of Mraz Brewing Company. "Mike didn't want to inherit

The wall of taps at Device Brewing Company in Sacramento. *Author's collection.*

all that risk; he didn't want to owe the bank a bunch of money, he didn't want investors dictating what we could and couldn't do, so we decided to do the opposite and start smaller."

Looking back, Anthony says he would have figured out a way to have more startup capital so he could have purchased larger equipment from the start. He says the upgrades he's had to make cost him more in the long run.

When you consider all the things brewers have to pay for—rent, utilities, ingredients, things like bottles and kegs and equipment—it's not surprising that they need a lot of capital. But decisions about money go beyond the brewery. Anthony gave up a six-figure engineering job to open Device. Other brewers continue working their day jobs to pay the bills. For those brewers, they are often working seventy- to eighty-hour weeks.

"We both kept day jobs, which was really a struggle," Daniel Moffatt says. Both he and Bojescu kept their retail management jobs as they got Fountainhead off the ground. "There was a little risk aversion in there because I can't just walk away from a steady job with benefits."

Moffatt ended up quitting his retail job in the early part of 2017 to brew full time when the pair saw how his time split was affecting the brewery. "I

think our growth pace was definitely slowed down due to the double jobs, and we could have grown at a more rapid rate if we were dedicated here from day one," Bojescu adds.

Whether using investors, going it alone or working two jobs, Robertson says there's one thing all brewers seem to agree on: they wished they had started with more money. "I asked ten or twenty breweries, 'If you were going to do it again, what would you do differently?' And almost all of them said start bigger. They started too small."

THE EXCELLENCE OF EXECUTION

Coming up with a business plan and finding the funding are the first steps toward owning and operating your own brewery. Implementing that plan? It's a lot easier if you have experience. By the time you read this, Hoey and partner Rob Archie (who also owns Pangea Beer Café) will have opened Urban Roots Brewing & Smokehouse. It's Hoey's third time playing a major role in brewery operations.

"I've been able to take almost twenty years of experience now and previous mistakes and just observing what works and what doesn't and really pile all of that knowledge into one project. That's not to say we won't run into our own challenges, but it's a completely different game coming in with a plan with a stronger business background with a better-financed project," Hoey says.

But most of the brewers in the Sacramento region don't have that experience. For many, this will be the first time they've run a business and certainly the first time they've operated a commercial brewery.

"Running a brewery is certainly not all about the brewing. As a business, it's very challenging," admits Crooked Lane's Teresa Psuty. Like many brewery owners in the area, Psuty and her husband began as home brewers. Psuty is part owner of the brewery and also the head brewer. That means she had to learn the business end and also had to figure out how to take the recipes she perfected in her garage and scale them to a commercial level.

"In the year leading up to us actually doing the construction, we had the lease on the building, we knew we were doing the brewery. I just went around to other brewers and said, 'Hey, do you mind if I look over your shoulder for a day when you're doing a brew day?' [I] went through this

with five or six other breweries locally and regionally and just learned a lot about what's different between home brewing and commercial brewing."

Not only do they have to know how to brew beer on a commercial level (or hire someone who does), but in some cases they also have to know how to build a brewery. That's exactly what Chris Powell and his partners at West Sacramento's Jackrabbit Brewing did. "Once we actually got our permits and could build stuff, we were here late at night after work, jackhammering out the concrete to put in the trench drain and stuff. We started assembling the equipment. We got a welder, and I taught myself to weld."

Once brewing operations are up and running, often the brewery owners are doing all the work themselves. This means long days that are taxing on your life inside and outside the brewery.

Julien Lux had traveled halfway around the world from France to Sacramento to follow the woman he loved. Shortly after marrying her, he quit his job and opened New Glory Brewing Company. "For the first year, it was really challenging, first year and a half actually," he says. "You're starting a brand-new marriage, you're starting a brewery and you're quitting a job that was paying you very well to just go work sixteen hours to make nothing."

Dave Estis from Oak Park shares a similar tale: "It was seven days a week, sixteen hours a day for a while. It was bad."

If you're blessed with success, you'll most likely have to hire employees, which means payroll, benefits and extra insurance. Because Oak Park is a brewpub, the owners had no choice but to have employees from day one. "Everyone told us, 'You're going to have to hire twice as many people as you think you need because half of them are going to suck so bad,'" says Tom Karvonen.

Success also can mean growth. For some breweries, it would be a question of opening a second taproom or maybe another production facility.

"It does kind of sit in our minds that a production facility would be nice, but would it be better to have multiple locations that are like this? Where you can bring your kids, bring your dogs," Moffatt wonders.

All of this adds up to the often-stressful lives of these small business owners getting their businesses off the ground.

"Not just business ownership, but running a commercial brewery," says Device Brewing Company founder Ken Anthony. "There were certainly moments where you go, 'Maybe this wasn't such a good idea.'"

HERE FOR THE BEER

None of this matters without the beer. You have to know how to make it, and what's more, you have to know how to make it well, right away.

"Beer quality has to be there," says Hoey. "There are so many breweries in Sacramento, and so many breweries that have identified Sacramento as a good beer town are now shipping beer here that if you don't bring your A-game, people are going to start to notice."

Track 7's Geoff Scott agrees: "Now more so than ever, it's very important to come out of the gate with high-quality beer because the consumer is that much more educated now. They know the beer market has grown immensely in the last five and a half years, and people's knowledge has grown immensely in the last five and a half years in Sacramento, and they know what they want, what they like and they want good, quality beer."

Where breweries may have had time to perfect their recipes before, now they must not only make good beer right away but also make beer that will make people take notice. It was a challenge Lux discovered shortly after opening New Glory.

"You want to make sure this succeeds, so you are kind of playing it safe, so we started with just standard beers," Lux says. "People were not getting that excited about it, and I wasn't happy about it either. 'Cause I was like, 'Man, this is kind of boring.'" Soon after, New Glory began making beers that Lux says you'll either love or hate, but either way, they will get you talking.

"Brewing is an art as well as a science, and you need both of those to be successful long term," says Grossman. "You need to be creative on the artistic side and innovative on the beer development side, but you also need to have strong quality control roots."

Former *Sacramento Bee* beer reporter Blair Robertson says, "I think there several ways that a brewery can succeed. You can make amazing beer and just sell the heck out of that. Or you can make really good beer and make people feel good about it."

And part of making people feel good about it is found in the taproom.

Service with a Smile

It's the final piece of the brewery success puzzle: how you serve the beer. Running a brewery with a taproom means you're a production facility and customer service location.

"As we continue to grow, quality and customer service and the whole vibe and the feeling that people have about their brewery, it needs to be top-notch," says Robertson.

As a brewery owner, you have to not only balance the budget but also the beer with the experience your location offers. It's something Hoey took into account as he worked to open his new Urban Roots location.

"It's going to be an experience like they really haven't seen in Sacramento. We do have a couple of brewpubs, but not on the scale that we're doing," he says. "We've got a sixteen-thousand-square-foot building, so plenty of room for the brewery and a nice big restaurant. So we've got the space to do both, and we're right on the grid."

What the brewery looks like and feels like is becoming more and more important. When this craft beer boom began, the warehouse location with a couple of wooden picnic tables was the norm. Now we're seeing breweries

Mark Bojescu helping patrons decide on beer at Fountainhead Brewing Company. *Author's collection.*

step up their interior design, trying to call back to earlier days when brewpub owners strived to make their locations comfortable.

"A lot of people used to call this their living room because it's a comfortable space," Rubicon founder Ed Brown says while sitting in the brewpub. "The design of this place has worked; it stayed current."

"That industrial park grittiness is eventually going to get old, it's going to become a cliché and you're going to have to elevate it somehow," says Robertson. "Crooked Lane is beautiful—high-end, walnut bar and countertop, custom furniture, a pass-through to the patio, amazing patio. That's the next level."

Brewery owners must also play interior designer. They have to craft their locations to be welcoming and comfortable. They have to make an interesting setting without being cheesy.

Oak Park Brewing is a good example of how hard that balance can be. Estis describes the décor as "kind of Victorian-industrial, steampunkish look without trying too hard to do steampunk."

If you go to Sactown Union, you can see just how much work was put into the taproom design, from the light fixtures, to the chairs, to the bar back designed in the likeness of Sacramento's Tower Bridge. "Everything is deliberate. We didn't just throw out some picnic benches and call it good," Gardner explains.

So Why Do It?

Brewer, businessman, interior designer—these are just some of the qualifications needed to open a brewery and taproom or brewpub. Brewery ownership requires long hours, a lot of money and even dedication. So why do it?

Every local brewer will tell you: it isn't to make money.

"You're never going to get rich doing it. If you expect to come into brewing and get a bunch of glory and prestige and get rich, you should go find something else to do," says Sactown head brewer Michael Barker.

Glynn Phillips agrees: "At this level, it's not a get-rich thing. It's a lifestyle, and it's being proud of what you make and what you do and how you're doing it."

And that's just it. Beer is a way of life for the brewery owners and beer makers.

"I just decided I wanted to start home brewing and decided that's what I wanted to do for a living, and I haven't looked back," says Hoey.

"For me as a home brewer, it was just when I was brewing at home, [owning a brewery] was more like a dream," says Moffatt. "It's just chasing your dream. Opportunity only comes around once in a while, so when everything lines up, the beer geek inside of you who's been brewing at home can't wait to get your hands on it."

Lux says that for him, becoming part of the brewery brotherhood was meant to be. "Just one thing led to another where it just kind of became an obsession. Craft beer was kind of like more of a way of life than anything."

Whatever the reason they started brewing, the reason they continue is simple: a passion for beer.

CHAPTER 7

NEAR BEER BUSINESSES

There's something else brewing in the Sacramento region thanks to the craft beer boom: entrepreneurial spirit. We're talking about businesses owners who have either evolved to take advantage of the popularity of craft beer or have seen a niche in the industry and are now filling it. These are what I call "near beer" businesses, not because they are making nonalcoholic beer, but because the business owners want to be near beer.

"[Craft beer] has that growth effect where other businesses are created," says CCBA executive director Tom McCormick. In terms of businesses and jobs, 2016 economic data from the CCBA showed there were more than 900 craft breweries in California creating more than forty-nine thousand full-time jobs. The 2012 CCBA economic report expands more on these jobs: "The jobs provided by the craft brewing industry can be seen in direct brewing activities from brew-masters and warehouse management to industries as diverse as agriculture, manufacturing, construction, transportation and the many other businesses that support the craft brewing industry."[54]

The Sacramento region is no different. From traditional bottle shops to marketing to not-so-traditional ice cream, the business of beer without actually making beer is becoming an industry all its own.

Beer Pairing: This beer pairing is a free choice, with one caveat: you have to get that beer from your local bottle shop or take the book to your local taproom. It has to be a business that may not have otherwise existed (or certainly wouldn't be thriving as it is) without the craft beer boom the Sacramento region has experienced.

Crafting Evolution

Ask anyone in Sacramento where to find the best selection of craft beer in the region, and they are bound to mention West Sacramento's Roco Wine and Spirits. The small liquor store has created a big following thanks to its incredible selection and the staff's deep beer knowledge but mostly its owner's uncanny ability to evolve with the changing trends.

"Our experience was mostly with liquor stores," Roco owner Ro Nayyar says. That's a bit of an understatement. His family has been in the liquor store business for nearly two decades. They opened Roco in 2010 with a very specific focus. "What we learned from our prior stores is that wine is really big," he says. "So when we opened this place, we started doing wine tastings."

While the wine business was strong, he soon found his customers were demanding something else: craft beer.

"Customers kept coming in here, and they're like, 'Could you carry Delirium Tremens for me?' And then I called my sales rep, and I say, 'Can I get Delirium Tremens?' And it's $120 a case, and we're like, 'Wow, for a beer?!'"

From the outside, RoCo Wine & Spirits looks similar to any other liquor store, but it has become known for its craft beer selection and newly opened taproom. *Author's collection.*

That was the beginning of his shift to craft beer. Even now, he still finds it hard to believe that people are willing to pay twenty or thirty dollars for a beer. But in the customer service business, what the customer wants, the customer gets.

"So we started going out there, started learning about beers," he says. "And then we started becoming a little bit more popular in the Sacramento scene. We got our selection all the way up to 1,500 different bottles."

Roco started gaining traction through both traditional and social media, especially because Nayyar had a knack for getting his hands on rare releases that other bottle shops couldn't find. Where some business owners might stop and enjoy the success, Nayyar found more opportunities to grow in the beer industry.

"I also started growing hops," a move sparked by a simple suggestion from New Glory Brewing Company owner Julian Lux. Nayyar now has one of the largest hop farms in the region, something we'll explore in a later chapter. In addition, Nayyar has recently added yet another title to his résumé: taproom owner—a move once again dictated by the changing trends.

"So before some of the customers can convert over to craft beer, they're like, 'I don't want to spend that much money; I want to be able to taste it.'" In response, Nayyar converted a portion of his liquor store to a taproom. He has about a dozen or so beers on tap. He offers flights and pints. He's also introducing whiskey tasting, though that's a different book.

The taproom is the perfect extension of Nayyar, who everyone already seems to know, because now it allows him to get to know them. "That's just mind-blowing to me, how much I am learning about my customers," he marvels. "It gives you an avenue to get to know these people better."

Store owner to craft beer purveyor to hop farmer to taproom operator—all part of the evolving strategy to stay relevant in the ever-growing beer business. "Listen to your customers and change your strategy according to that," Nayyar says.

"When we started out, we were a liquor store. We've become a craftier store," he says. "We take a little bit more pride at that. We are a craft store."

Brewfest Management

Evolving is not something Scott Scoville and his company, Beers in Sac, set out to do but was something they had to do.

"When we got into it, it was kind of a typical labor of love. We didn't really know what it was or what it was going to be, but we knew we wanted to be part of the Sacramento beer scene," Scott Scoville says.

Scoville and his fantasy football buddy (yes, this is how these things get started) Ted Rozalski initially started Beers in Sac in 2014 as a website aimed at keeping beer lovers informed about where their favorite brews would be served. "[It was a] pretty unrealistic idea, but we dove right in and started doing it and realized not too long into the process that unless you completely automated it, it was going to be a nightmare to keep up to date," Scoville says.

After three months and endless calls to bars, restaurants and breweries, the company changed directions. "We started to find out what people wanted and where there was a need in the industry, and a lot of it surrounded events." Beers in Sac shifted from just a website to an app to help folks living in the region to track the ever-growing list of beer events.

"From the get-go, it was mostly about events and marketing." Promotions and marketing led to full event planning. Scoville says, "We were doing craft

The Yolo Brewfest is just one of the events managed and organized by Beers in Sac. *Beers in Sac.*

A patron taking a photo of her beer at the Elk Grove Brewfest. *Beers in Sac.*

beer events, for mostly festivals, then started doing catering, public/private events and started to organize brewfests, and it kind of grew from there."

Beers in Sac now organizes and manages four brewfests a year, including the Elk Grove and Yolo Brew Fests. It does marketing and promotions for another fifteen to twenty events each year, caters for another forty and also rents out beer trailers, beer trucks and jockey boxes.

The company has also grown, and while this is not Scoville's full-time job just yet, Beers in Sac has hired a handful of full-time employees. He says, "[We have] tried to have our hands in everything craft beer with the exception of the manufacturing side, which is the hard part."

A NEW FRONTIER

A love of travel, maps and of course beer helped launch one of the most original ideas to come out of the Sacramento region's craft beer scene. The company is called Sacramento Beer Frontier, but local craft beer lovers probably know it best as the Brewery Passport.

The Brewery Passport looks and feels just like the passport you use to travel the globe. Instead, you use these passports as an excuse to tour the region's beer industry. The man behind the passports is Aaron O'Callaghan, and like most great ideas, this one started over a beer.

"I was sitting down having a beer with Trent [Yackzan, Sudwerk co-owner] out at Sudwerk, and we were talking about the Sacramento beer scene and how it was expanding," recalls O'Callaghan. "At the time, he was on the board of the [Northern California Brewers Guild], and he said, 'Yeah, we're talking about doing a map,' and I said, 'Hey, do you want me to do a map? I love maps.'"

As it turns out, he wasn't the only one. O'Callaghan created a map for Sacramento Beer Week showing every brewery in the region. It was a hit. And while everyone from the brewery owners to the beer drinkers liked the map, O'Callaghan was unsure it was serving the region's growing craft beer scene as best it could.

"It sort of seemed silly to have this just be a map that you might see hanging in a taproom here or there," he says. "I wanted to connect people with that map and kind of develop a little bit of an experience around it."

That's when he came up with the idea for the passport. Beer lovers get a stamp in their passport every time they visit a brewery. Get so many different

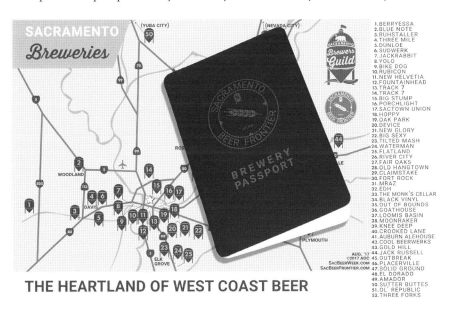

The Sacramento Beer Frontier's Brewery Passport and map. *Sacramento Beer Frontier.*

stamps and receive a reward. Get more stamps, get more rewards. A good idea that only lacked one thing—money.

O'Callaghan did what any modern-day entrepreneur with a big idea does: he turned to crowd sourcing. He launched a Kickstarter campaign aimed at raising $6,250 that would cover the costs of the passports, the stamps and the rewards. With the breweries on board, he was able to raise that money and then some in under thirty days.

Sacramento Beer Frontier launched its first official batch of passports in January 2017. By June, the company had sold more than 1,700. O'Callaghan says his company is now self-sustaining, and the biggest challenge is constantly updating the passport to reflect the new breweries that have opened and, unfortunately, take out those that have closed.

"Before Amanda and I had kids, we got to travel a bit and got a kick out of new places just for the sake of going to new places. That's how we were; we enjoyed traveling. So it's sort of funny now that we have young kids, not going too far afield, I made my own passport to go check out Sacramento basically. It's been fun, it really has."

PARTIES ON PEDALS

If you've been to downtown Sacramento on the weekend and maybe even some weeknights, you've probably seen Chris Ferren-Cirino's business. It's hard to miss. He owns the Sac Brew Bike. Those parties on pedals have become a staple of the region's beer scene, and it's an idea the Sacramento native borrowed from another craft beer mecca.

"We saw the concept in Portland, Oregon," Ferren-Cirino says. "We had just moved into our place. We heard something coming down the street, we opened our window and we saw this bike rolling by with people having fun, laughing, singing, enjoying themselves. It was just this big, slow, rolling contraption that I saw everyone was pedaling."

Ferren-Cirino says he always wanted to be a business owner. Once he saw the beer bikes and how excited people were for craft beer in the Sacramento region, he knew he had found his opportunity. So six months after seeing the bikes roll down the streets of Portland, he gave his notice at work and moved back to Sacramento. In May 2014, the first brew bike was rolling down the streets of Sacramento.

The tap lineup at Big Stump Brewing. *Author's collection.*

"It seemed like people were really getting excited about the beer scene in Sacramento," Ferren-Cirino says. "I thought it would make a really, really great concept for Midtown just because of the craft beer and the Midtown vibe."

The response has been overwhelming. Since opening, Sac Brew Bike has grown to five bikes. They service Sacramento's Midtown area, with occasional trips to West Sacramento and into East Sacramento's Fab 40s during the holiday season. The company even has a partnership with Big Stump Brewing Company in downtown Sacramento, which includes discounted beer and a behind-the-scenes tour for the guests if they'd like.

"Part of why the Brew Bike likes us so much is as of right now, we're the only production brewery on the downtown grid," says Big Stump owner Alex Larrabee. "People that are into craft beer are also naturally curious about the process."

"I think Sacramento was due for something really fun, exciting and different…and that's why we tried to bring what we did, but I think the craft beer culture definitely helped," Ferren-Cirino says.

YOU SCREAM, I SCREAM

Ice cream might be one of the last businesses you would associate with craft beer, but Jesse Sahlin and the Craft Creamery are trying to change that.

"I create an ice cream that I'm able to infuse with between twenty-six and thirty-eight ounces of craft beer per gallon. It has all the ABV. We don't adjust the beer; we don't do anything like that," says Sahlin.

Sahlin has a master's degree in applied mathematics from UC Davis. That obviously has nothing to do with ice cream, but it was during his time at Davis that he was approached about buying the Davis Creamery. He did, and it was there where he found the inspiration to explore beer ice cream.

"One night, to be completely honest, it was one night I was in the back room and I was drunk," Sahlin says. "I had the machine running, and I looked in and I realized there was no flavoring in the machine, it was just the sweet-cream base."

He had no flavoring, but he did have a bottle of Guinness, so he did what any of us would do in that situation: "I kind of shrugged my shoulders and started dumping it in the machine. The ice cream that came out was God-awful; it was horrible. It was slushy and nasty and icy and set up terrible. But right then, I decided I can see the potential in this."

Sahlin would spend the next three and a half years developing a process that allows him to create what he calls "super-premium ice cream imbibed with your favorite beer."

Working with local brewers, the Craft Creamery has already developed hundreds of flavors, including combinations like Crooked Lanes Pupup Baltic Porter with English toffee and Maldon salt or Mraz's Saison Je' with blackberries. The most important aspect of his recipes is trying to keep the essence of the beer recognizable in the ice cream.

"There's going to be something that every single person gets out of things. I'm going to get something different out of a beer than maybe you would, than maybe the next person would and the next person would. But the brewer, they always have something they put in there that they intend to have reflected, and that's what we want to get," Sahlin says. "We want to see those one or two flavor profiles that he or she wants to see pop; we want to pop in the ice cream."

Stouts and dark beers are the most easily translated into ice cream, but Sahlin says he can work with any style beer. In fact, he says sours end up making something closer to frozen yogurt. The Craft Creamery isn't limited to just beer; Sahlin has also developed a process to make ice cream infused

with 80-proof liquor. He also works with local coffee roasters to develop ice creams for them.

Sahlin used crowdfunding to get the Craft Creamery off the ground but says it will eventually be housed in a bar he is opening in downtown Sacramento. After that, the sky is the limit. "The ultimate end goal is to see the Craft Creamery set up in cities across the country, each one of them being a unique hub in the sense that, that hub, the Craft Creamery in Sacramento, it's going to showcase what Sacramento has to offer, the Craft Creamery in Austin would do the same thing."

CHAPTER 8

CHANGING CULTURE

I t isn't just beer that these breweries are changing in the region; it is the entire culture, from where and how we socialize in person and online to changing not only what we're drinking but how we're drinking it.

"It's a huge change. I think when [craft beer] first started blowing up, people wanted to figure out what was good beer and what was bad beer," says Robertson. "They needed to educate themselves, and I think, like most of us, they found benchmarks and then they learned why they liked that beer and they started talking about these ten different hop varietals and all this other stuff."

Breweries are bringing people together in a way that just didn't exist before for many neighborhoods. Where once bars or restaurants were the only social hangouts, you now have these dog- and kid-friendly locations where the beer is the main attraction.

"I became a big fan of these places when I had kids. I've got a two-year-old and a four-year-old. These are the places where I can sit down with my spouse, Amanda, and the kids can kind of do their thing, other kids running around," says Sacramento Beer Frontier founder Aaron O'Callaghan. "There's vibrancy to these places. It's a low cost of admission. If you buy a beer or two, the table is yours for ninety minutes to a couple of hours."

"It's so nice; you don't have to go to a cheesy bar. You can go and everyone here is about the beer," agrees Robertson. "Beer brings everyone together. You don't even care if you're a conservative or a liberal, a schoolteacher or

a dentist. When you're sitting having a beer, it doesn't really matter. So that is a nice thing."

And it's not just about the drinking. The breweries are serving as event centers, hosting events like an independent comic book expo show at Big Sexy Brewing Company or Suds & Succulents at Flatland Brewing Company in Elk Grove.

The beer makers recognize this. They know that in order to succeed, they can't just move into a community; they have to become a part of it. "We have to be more than just a guy that makes beer," says JE Paino. "Beer is certainly a part of what we do, but our real strength that separates us from the big guys is we can be part of the community in a way the big guys can't."

Beer Pairing: Sactown Union's Freedom Ryder Rye Pale Ale is a good example of how a brewery gives back. Proceeds from the sale of this beer go toward a Sac State scholarship for students studying to be educators in the inner city. So drink up.

PART OF THE COMMUNITY

"Our tag line is 'We're not just brewing beer, we're brewing community,'" says Sactown Union co-founder Quinn Gardner. When he says it, he means it, because he knows that his brewery can be a community resource. "[We want to] use this platform for something more than just beer."

And he's not alone; these small businesses are having a big impact on their neighborhoods.

Since opening Sactown Union, Gardner and his team have held fundraisers for local dog shelters and to raise money for national tragedies. He also uses his seasonal beers as a way to give back and pay tribute to those who shape our world. "We call it the 'Revolutionaries Series.' It's our seasonal lineup, but instead of calling them fall, winter, spring etc., even though the beer is matched to the season, they are named and brewed in honor of various social catalysts, people who made our community better. In turn, each one has a built-in contribution to a local nonprofit." That includes the aforementioned Freedom Ryder (which you should be drinking right now) and the First Responder Helles Lager, which helps the Sacramento Firefighters Burns Institute. "So again, it's that sort of greater sense of we have this platform, we need to use it."

Sierra Nevada's Ken Grossman says giving back to the community is not only good business for brewery operators but should be looked at as their responsibility. "Support the people who support you," he says. "It's an industry that serves alcohol, produces alcohol, so you have to act responsibly in your community in order to gain that respect."

That respect is something that it appears all the region's breweries take very seriously.

"I want Track 7 outside of the beer industry to be known as a business that really tries to give back to the community and is a part of the community," says Track 7's Geoff Scott. "We can donate beer to the children's home, which is right across the street from our Curtis Park facility, to help them raise money to provide better living situations for kids."

"We do a charity of the month program every month, and we try to keep it to a local charity," says Mraz's Lauren Zehnder. "We choose a beer, and then 20 percent of the sales of that beer go to whatever charity we choose for the month."

Breweries are finding a lot of ways to be part of the community beyond charity. YOLO Brewing allows local bands to play in its beer hall. It turns out their most popular band is an '80s cover band made up entirely of high schoolers. "They reached out to us to come and play in here one night, and we thought, 'Sure, why not? It will be great.' We now have them booked at least once a month because they pack the place," says YOLO CEO Rob McGormley. "It's amazing to see that kind of community support where people just come out because they know they are going to be here."

Titled Mash is providing sponsorships for local sports teams. "We sponsor an indoor soccer team," says co-founder Derrick Prasad. "They call themselves the Winter Borthers, which is the name of our winter stout."

Breweries can play an integral role in the community by being a source of revenue, attracting tourism and by the simple act of hiring employees. Grossman points to how Sierra Nevada grew up alongside the town of Chico. "When I built the brewery in 1980, I think the town was less than half as big as it is today. We were a very small employer; we employed one part-time [worker] in the beginning. Today, we're a pretty significant employer; we have close to four hundred people in the Chico area."

Whether it's providing employment, hosting a fundraiser or donating beer, Scott it all boils down to one simple idea: "Ultimately, the community is the most important thing. They're the ones that support us, and we definitely want to be known for supporting them."

BREWS AND VENUES

"Breweries historically were sort of a social meeting place, so I think we still tap into that historical vein. It's just that modern tastes are much different," says Big Stump Brewing Company owner Alex Larrabee. "I can't imagine people in the 1780s doing yoga in Philadelphia in a brewery."

Probably not, but that's exactly what you can find people doing at Larrabee's brewery in downtown Sacramento and many other breweries throughout the region.

"It's sort of been an adventure teaching yoga in a beer space," says Balanced and Blessed's Stephanie Dodds, who teaches beer yoga at Big Stump. "People think we're doing yoga with beer. It's a yoga class, and you earn your beer afterward. It's kind of like getting your sweat on and getting rewarded."

Yoga is just one example of a growing trend of breweries serving as beer factories and also event centers. Big Stump also hosts Beads and Brew, while in the summer of 2017, Big Sexy Brewing Company held an independent

Students must work up a sweat at yoga offered at Big Stump Brewing Company before they can enjoy the beer. *Author's collection.*

The big sign at Sacramento's Big Sexy Brewing Company. *Graphics & Growlers.*

Sac Indie Comic Book Expo event at Big Sexy Brewing Company. *Graphics & Growlers.*

comic book expo that featured fifteen independent artists and brought in about seventy-five people.

"That's what's so great about beer right now is that you can go to the source and get the freshest beer possible, but also there's going to be a live band or a great food truck or there's going to be something going on to where every time you go to the place it's new," says Flatland Brewing Company owner Andrew Mohsenzadegan.

Flatland hosts its own unique event called Suds & Succulents with the help of Elk Grove nursery the Secret Garden. "They came to us and said, 'Hey,

Participants getting a lesson in succulents and suds at Elk Grove's Flatland Brewing Company. *Flatland Brewing Company.*

we have this idea that we want to pitch to you guys,'" says Mohsenzadegan. "All we do is get the tables set up, put tablecloths down and promote it." Of course, he admits not all events are this easy.

Whether it's succulents or yoga or beads, brewery owners say these events help bring fresh faces in to their business.

"Beads and Brew is funny because it's not our most profitable night, but I think it ultimately kind of engages people who otherwise would maybe not be spending time at the brewery," says Larrabee. "There will be thirty or forty women in their fifties beading and drinking our blood-orange beer."

"A lot of these events come with a beer. Once you wet the whistle, it's like 'oh, let's have another one!'" adds Mohesenzadegan. "It's just increased revenue for the brewery; it's brilliant."

Even if the events aren't always easy.

"Something random happens every single class that's beer related," Dodd says. On Mother's Day weekend, with a class of hungover students, she says they had to make way for a man who arrived at Big Stump to pick up hop waste for composting. "He came in and he has to wheel, like, seven trash

cans full of this stuff out, and there's no other way around and he lives like an hour away, so he had to do it during this time. So we literally had to do yoga while the guy was wheeling the hops back and forth."

BEER ON THE RUN

That cultural shift hasn't just changed the way people socialize. Believe it or not, beer is changing the way people exercise. Don't believe it? Just head down to New Helvetia in Sacramento every Thursday (weather and daylight dependent) for the Sloppy Moose Running Club.

"My wife and I used to live in Spokane, Washington, and we were in a running club up there. It met once a week at an Irish bar. It was so cool how many people we met," says head Sloppy Moose Kyle Blaikie.

But when he moved to Sacramento, he says there was nothing like it. Around that same time, New Helvetia had just opened its doors, and Blaikie says while visiting the new brewery, he told his wife it would be the perfect place to start their own running club.

"This guy was right behind me, and he goes, 'This would be a perfect place for what?' I kind of look at him awkwardly and I said, 'It would be a good place to start a running club. You know, go run three miles and then drink beer here.' And he's like, 'Let's do it!' And I go, 'Who the heck are you?' And he goes, 'I own the place!'" says Blaikie.

Sloppy Moose Running Club members on the run outside New Helvetia Brewing Company. *Author's collection.*

Sloppy Moose runners earn these shirts after participating in five runs. Shirt owners get discounts on certain beers on run nights. *Author's collection.*

New Helvetia owner David Gull says he had already been considering starting a running team, but Blaikie's previous experience really sold him. "He goes, 'I'm going to start something called Sloppy Moose Running Club. The running club I was a part of, the Flying Irish in Spokane, they started out really small, and they're up to like two thousand members.' And I go, 'Why don't you go ahead and start that then.'"

The Sloppy Moose meet on Thursdays from February to early December. It's nothing too long or too serious, with the runs usually ranging from one and a half miles to three miles. Sometimes the runs even have themes, like the cargo shorts run aimed at celebrating the less-than-fashionable men's attire.

"It's what sets us apart from serious running groups. We're kind of like a social group that runs and drinks beer," says Blaikie. "It's a great idea, right? It's like a preemptive strike: I'm going to have a couple beers tonight, why not run a couple miles before and burn off a few of those calories."

The group has grown considerably since the early days, when it was just Blaikie, his wife and a couple of friends. He says now they regularly have around 150 runners on any given Thursday. And there's more incentive than just some exercise. If you participate in five runs, you get a free T-shirt. The T-shirt gets you discounts on select beer on run nights.

The runs became so successful and popular that a few years ago, New Helvetia and the Sloppy Moose Running Club began holding the Sacramento Beer Week 5K. It's a real race that raises money for a local charity.

"When my wife and I realized the group got this big, we have such a reach, we should probably put that reach to good use. So we established it as a nonprofit recognized by the State of California. We're working on park cleanups, I want to do scholarships for kids, we do food drives and clothing drives every year for our year-end party. It's really cool how the community gets together, and it's all centrally located around running and drinking beer."

All of this is the result of someone who wanted to have a little exercise, a little beer and a whole lot of fun.

"It's built a community around New Helvetia that I never could have anticipated," says Gull. "My running team concept could have never accomplished what Sloppy Moose has accomplished."

CHAPTER 9

BEER AND SOCIAL MEDIA

I t's fair to say nothing has changed our culture more over the last decade-plus than social media. Whether you Facebook, tweet, snap, insta or blog, social media keeps us connected just about every second of every day. In June 2017, Facebook reported that its number of daily users reached 2 billion…2 billion! Earlier in 2017, Instagram reported 700 million daily users, Twitter at 328 million. No matter your social network of choice, that's a lot of eyeballs, and the Sacramento region's beer makers have noticed.

In the next section of this book, we're going to look at how social media is playing a huge role for both the beer makers and beer drinkers in the region.

Beer Pairing: Raise your hand if you've ever logged onto Facebook or Twitter or Instagram and gotten lost in the comments of a particular post. OK, now put your hands down and open a Just Here for the Comments Double IPA from New Glory Brewing Company.

Harnessing Social Media

"Social media is really powerful. I think the ability for us to talk to one another without having to buy advertisement is critical," says Ruhstaller's JE Paino. "I think it's why craft has grown so much, especially in Sacramento."

"I credit social media to the full extent because it's through word of mouth and people that's made Moonraker the name that it is," says Moonraker owner Karen Powell.

From the smaller neighborhood breweries to the big brewers like Track 7 and Knee Deep, each has several hundred to several thousand followers on its social media channels. Facebook and Instagram are kings, letting the breweries connect directly with consumers in a way that just didn't exist ten years ago.

"The whole advent of technology has helped a small, grassroots-type industry gain traction and thrive. It's helped spread the word far and wide on a very low budget," say California Craft Brewers Association executive director Tom McCormick.

In this ever-growing craft beer market where breweries are already competing for limited store shelf and tap handle space, they are also competing for eyeballs online.

"It seems now more than ever, you really have to start getting on your marketing game and your social media presence to help distinguish yourself," says YOLO Brewing Company CEO Rob McGormley. "If you're not going to be someone who specializes in sours or specializes in Belgiums or a particular type of beer, if you're going to just do different kinds of beers across the board, then you really have to do a lot of self-promotion and get the word about as to what you're doing and how you're doing it."

That, of course, is easier said than done.

"I don't think we've done as good of a job as we should be doing on social media. It's definitely something we're going to start looking at more," adds McGormley.

Most if not all of the accounts are run by the brewery owner or brewer or employees, and few if any of them have any sort of marketing or social media background. That means they are learning the ins and outs of effective social media marketing on the job.

"I remember it was the beginning of 2013 when I created the Instagram account for Knee Deep, and it was actually my own personal page for the first few months," says Knee Deep marketing manager Andrew Moore. "You know, it's photos of me and my family, and from there as we started marketing with our little Hoptologist character, I started incorporating him in my Instagram, and I went from a few hundred friends—that were friends and family and college buddies—to I think we're right at twenty-three thousand followers."

Moore says he studies other companies to see how they market their brand and how social media is being used throughout the craft beer industry. "Social media is huge; it plays a big role. I think it's only going to continue to grow, and if people use it the right way, it's going to help them out, definitely benefit them."

Of course, the use of social media has not always worked out well for brewery owners. Take the case of the brewery formerly known as 12 Rounds. Owner Daniel Murphy used his personal Facebook page to criticize women's marches that were held across the country shortly after the election of President Donald Trump. That led to backlash and the discovery of other posts about former president Barack Obama and Muslims that people found offensive.

"It just defies common sense, right? If you're going to be in the retail business, you want to like everybody. And if you don't, you got to keep your mouth shut," says former *Sacramento Bee* food and beer reporter Blair Robertson. "There's screen grabs, and those just don't go away." Robertson describes the 12 Rounds controversy as one of the few negative stories he ever covered while on the craft beer beat.

Despite apologizing, the damage was done, and in April 2017, Murphy announced (via Facebook) that he and his wife were leaving the brewery.

"This was my dream and my life. I put all of my heart, soul and money into it," he posted. "I cannot sit here and watch all of our investors and workers lose everything too. Many of them have put in a lot of heart and soul too."

New owners have since taken over the brewery and announced that 12 Rounds would be renamed Porchlight Brewing Company. Where did they make that announcement? Facebook, of course.

BEER ENTHUSIASTS TAKE OVER FACEBOOK

It's not just the brewers and breweries that are active on social media. If you're reading this right now, there's a really good chance that you belong to the Sacramento Beer Enthusiasts (SBE) page on Facebook.

"Somehow, I came up with Sacramento Beer Enthusiasts. I still don't know why I chose that name; it literally could have been Six Guys Drinking in a Backyard," says page founder and administrator Russell Kay.

Had he named it that, chances are SBE wouldn't have become one of the largest and most active beer lover groups on Facebook. As of early

2018, there more than 16,100 members. That's more than the Bay Area or Chicago beer lovers' groups. It's significantly more than any group in a quick search of other beer-loving areas like Denver, Portland or San Diego. And it all started with a six-pack of friends who wanted a guys' night out.

"Our wives were doing girls' night out once a month, so we decided to do a boys' night out once a month," Kay explains. "And we came up with this great idea [because among the six of them,] everybody would bring a different six-pack and everybody would share their beers. So we started calling them beer meetings.…I created the Facebook page just so we could literally keep track of what we were drinking. So we knew what we drank and what we thought of them and so forth and so on."

That was in 2012, around the same time Sacramento really began to see the craft beer boom. And like that boom, the page was slow to grow at first, but then the floodgates opened. Kay remembers, "It took a year to get to fifty members. Took another year to get to one hundred members, but by January 2015, we were at a thousand."

In the three weeks between interviewing Kay and writing this chapter, the group added nearly one thousand more members. He says he gets anywhere from five to fifty add requests a day, and more and more of those are coming from outside the Sacramento area. That includes the Bay Area all the way to the East Coast. Perhaps part of the appeal of the page is that it's open to everyone, with the only rule being, leave the political posts to your personal feed.

"Our beer page is, 'Let's keep it beer, let's stick to beer because beer is something we can all agree on.' Some of us disagree on certain beers, like the famous Pliny the Elder—some people love it, some people hate it—but those are fun topics to discuss. The other stuff gets people to hate people. Beer is just fun."

The page has helped the beer industry grow as much as the beer industry has helped the page grow. SBE serves as a social planning site to tell your beer-drinking friends where you'll be imbibing next. It serves as a beer swap; miss out on the latest release, and someone else will be willing to trade with you. And most importantly for the Sacramento beer region, it's a place to keep your finger on the pulse of what's happening in area beer.

"If you look at the beer page, almost every brewery in Sacramento has somebody on that page," says Kay. "Whether they want to promote their beer page, keep track of the trends, whatever the case may be."

A "Beer Meeting" put on by the Sacramento Beer Enthusiasts. *Russell Kay.*

Those beer meetings that Kay and his six-pack of friends held in the beginning continue today, albeit on a larger scale, targeting a different brewery each month.

"We literally get as many people as we can there to help support that brewery for one day during that month. We just flood them with SBE members and hopefully give them a good sale on that day." Kay says the turnout is typically fifty to one hundred members, which out of a group of more than twelve thousand doesn't seem like much, but for the breweries an extra one hundred customers can really make an impact.

If nothing else, the SBE solidifies the idea that there is power in numbers. Robertson says that can also be a problem: "I have mixed feelings about a place like Sacramento Beer Enthusiasts, where there's a core group of serious beer people and then there's a lot of followers and wannabes, and they just do whatever the core group says is cool and they don't really think for themselves."

Still, like Spiderman, Kay seems to appreciate the idea that with great power comes great responsibility. That's why SBE tries to tie each of its events to a local charity and why he's now strongly considering turning the SBE into a 501c. That would allow SBE to run its own beer events raising money for disabled veterans and veterans in need.

Kay marvels at where the beer page started and where it is today. He credits a lot of that growth to the unique nature of beer bringing people together. After all, he was literally a guy starting a page for six beer-loving friends. Now he has thousands of them.

"I'm just here to drink beer, enjoy it and meet some great people along the way." That's a mission statement we can all "like."

PART III

THE FUTURE

BREWING FOR THE FUTURE

W hile the current beer scene in the Sacramento region is about as hot as it can be, there's always time to look toward the future of the industry. As it turns out, this region has been shaping the future of beer making for more than half a century. Even when commercial brewing was all but dead in this area, the University of Davis was fermenting the minds of would-be brewers, brewery owners and even the avid home brewer. In this next section, we'll look at how a university just outside California's capital became one of the foremost institutions for brewing science and how the men leading that charge continue to shape the brewing industry, as well as some of the other "educational experiences" this region offers without needing to get a college degree.

Outside of Washington, D.C., perhaps no city in this country carries more political weight than Sacramento. After all, the decisions made here set the course for the entire state, and in case you forgot, California is one of the largest economies in the world. Those decisions also affect the beer-making world, and the group that represents the brewers knows it. We'll look at how the group uses the location to its advantage and how it serves the brewers it represents.

Finally—the rebirth of the hop industry. Maybe. There are more hop growers now than there have been in years, but does it mean hops are truly coming back? We'll look at two of the region's growers, how they got started and the big challenges that face any chance of California's hop industry making a comeback.

We know for certain that beer will continue to be made and drunk in the future. After that, the future is full of possibilities.

Beer Pairing: In late 2017, UC Davis announced it was teaming up with Sudwerk Brewing Company to launch its own branded beer called Gunrock. It's described as a light-bodied lager and was developed by Davis alum Doug Muhleman, who plays a significant role in the brewing program. Also, it's named after the school's mascot, so that's fun.

UC DAVIS BREWING PROGRAM

On the outskirts of campus, nestled between grapevines and a parking garage, is the University of California–Davis Robert Mondavi Institute for Wine and Food Science. The location is a perfect representation of the building itself, a combination of agricultural and industrial. It's also home to the "leading provider of university-level qualification in brewing science and brewery engineering," and it's been leading the way since 1958!

"Back in 1956, a guy called Ruben Schneider, who was the technical director of the Lucky Lager Brewing Company in San Francisco, wrote to a guy called Emil Mrak, essentially saying, 'You should be teaching people brewing. You've got a wine program, you should have a brewing program,'" says Anheuser-Busch Endowed Professor of Malting and Brewing Sciences and current head of the brewing program Charles Bamforth, PhD, DSc.

Mrak was a world-renowned nutritionist and the chairman of the Department of Food Technology at the time. Just a few years later, he would be named chancellor at UC Davis. It's probably fair to say that if there was anyone who you would appeal to to get a brewing program off the ground, it would have been Mrak.

In the letter, Schneider said that with just a few modifications to the Food Technology and Viticulture curriculum, UC Davis could begin educating the next round of "Packaging Department Superintendents, Assistant Brewers and Brewmasters." In exchange for starting the brewing program, Lucky Lager proposed it would take on the UC Davis graduates as paid apprentices and continue their brewing education.

The offering included two two-year apprenticeships in quality control and two two-year apprenticeships as brewery journeymen, essentially learning

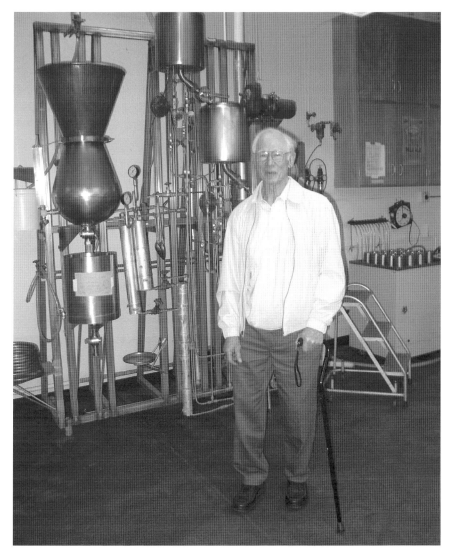

The late Ruben Schneider getting a tour in 2003 of the brewery he helped begin nearly fifty years earlier at UC Davis. *Charlie Bamforth, UC Davis.*

all aspects of production. These positions would pay $5,300 and $6,200 a year, respectively. Once complete, the trainee would be qualified to be a foreman or department head, and that experience would eventually qualify him to be an assistant brewer.

Lucky Lager had reason to push for this program. Beer making was expanding across the country, and in order to keep up, the company needed

qualified brewers. So with money from Lucky Lager; Frydenlund Brewing Company in Oslo, Norway; and the Master Brewers Association, UC Davis began its brewing science program in 1958, two years after that initial letter was sent. The eventual brewing technology course would be the first of its kind offered at an American university.

The first courses were taught by Herman Phaff, a fungal taxonomist. The first appointed brewing teacher was a man named Tommy Nakayama. But the program would really come into its own after Michael Lewis, PhD, took over.

"I was doing brewing research from 1962 to '64. In '64, I joined the faculty with the charge of starting an educational program in brewing," Dr. Lewis explains. "I established the instructional parts of the type of program that you're probably familiar with—that is, teaching people about beer, standup lectures and so on. I established a series of three lectures in the fall, winter and spring of the senior year of students: a lecture class,

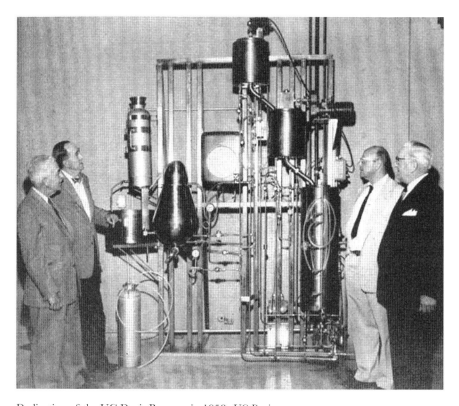

Dedication of the UC Davis Brewery in 1958. *UC Davis.*

a lab class and what I called a seminar class. That was the beginning of the educational process or the instructional process for undergraduate and graduate students at UC Davis."

Lewis had a long interest in brewing. When he was growing up in Birmingham, England, his uncles were pub owners whom he describes as "the great personalities" in his life. Their stories of beer piqued his curiosity and drove him toward his career goal. "If anybody asked me the question, I wanted to be able to answer, 'I'm a master brewer.'" Birmingham also happens to be home to the British School of Malting and Brewing, where Dr. Lewis eventually got a degree in microbiology.

By the early '60s, he was studying at UC Davis as a postdoctoral fellow. "I was lucky enough to be on the spot when the master brewers had just made an investment in research at UC Davis…so tremendously fortunate. Having been lucky once, I wasn't about to move on, stick with it, you know?"

UC Davis was lucky as well. Dr. Lewis helped build the program to one that would have direct influence on the beer industry across the country.

"At one point, I was able to say, 'I think I am responsible for the manufacture of 90 percent of Anheuser-Busch's beer,'" he laughs. "Because the head brewer at nine of their ten breweries was a Davis graduate." Even today, the influence remains, with Davis grads holding top positions at AB InBev with titles like "director of brewing" and "global vice president, innovation and development."

Dr. Lewis's most lasting legacy came in the form of his Master Brewers Program off campus as part of University Extension. It started in the late '80s in response to the rise of craft beer. "As soon as the craft brew industry raised its head, and of course it raised its head first here in California, I realized that there was an enormous potential, and the thing they would need most is educated brewers."

Dr. Lewis retired from the campus program in the mid-'90s but still leads the Master Brewers Program. About 40 students graduate from the program each year. After nearly thirty years, that's 1,200 UC Davis–educated brewers.

"That is a tremendous cohort of skilled, experienced, well-educated, thorough, problem-solving brewers in the industry. And they can provide a backbone for the industry, and I'm very proud of that," Dr. Lewis says.

He says sometimes the reach of UC Davis's influence on the beer world even surprises him. Take his story from when he took a tour of Boston's Harpoon Brewery: "As I was taking the public tour, the guy began the public tour by saying, 'All the brewers at this institution got their original training at UC Davis in California, and that is the reason we make such fantastic beers.'

And I nearly fell over, I literally fell over," he says with a laugh. "That was an astonishing thing to hear put out on a public tour…in Boston…at the Harpoon Brewery. They said, 'Oh yes, all our guides are taught to mention that and tell that story.' So I thought that was pretty cool."

Brewing with Bamforth

When Dr. Lewis retired from the campus program, Doug Muhleman (UC Davis alum and now retired Anheuser-Busch vice president of brewing operations and technology) stepped in to ensure that the program would continue to be a leader in brewing science and technology.

"Doug was adamant that there should be an endowed professor of brewing at UC Davis," explains Dr. Bamforth. That demand would lead to the next era for the UC Davis brewing program.

Dr. Charlie Bamforth joined the brewing industry in the United Kingdom in 1978 at Brewing Research International. He spent the next twenty years working with some of the world's largest brewers, including Bass Brewers, as well as researching and teaching. That combination of experience was exactly what UC Davis was looking for in its next brewery program head. So in 1999, he arrived at Davis as the first Anheuser-Busch Endowed Professor of Malting and Brewing Sciences.

Dr. Bamforth was joining the nation's oldest university-level brewing program with perhaps one of the nation's oldest brewery setups. "The first morning I arrived here, I had a meeting with the folks from Anheuser-Busch, and they said, 'You need a new brewery.' And I said, 'I have to agree with you.'"

With the help of Anheuser-Busch, Dr. Bamforth launched a major overhaul of the program. It would take around four years to get the new brewery up and running, replacing the brewing system the program had been using for the forty years prior.

"We had the old original brewery from Lucky Lager Brewing Company, and people loved it, they were charmed by it, and a lot of people learned how to brew on it, so it served its purpose well," he says. "Now we've built a decent brewery. We have something people can actually cut their teeth on, brewing on a really classy small-scale system."

But that was just the beginning of major changes for the brewing program.

In 2001, renowned winemaker Robert Mondavi made a $25 million gift to open the Robert Mondavi Institute for Wine and Food Science. It was a great gift to the university but one that would require Dr. Bamforth to move his new brewery across campus. The problem was, there was no place to put the brewery. By this time, Dr. Bamforth was chair of the Department of Food Science and Technology (thereby emulating Emil Mrak), and it was up to him to find the money to build a pilot plant.

Anheuser-Busch, specifically August Busch III, stepped up with a $5 million donation as long as matching funds were raised. That additional $5 million ended up largely coming from the tomato processing industry, as well as Ken Grossman's Sierra Nevada Brewing Company.

The result was the August A. Busch III Brewing and Food Science Laboratory. It is equipped with classrooms for theoretical learning that are just feet from the jewel of the program, the Anheuser-Busch Inbev Brewery, a glistening stainless steel facility where you can put that theory to practical use. There is also the state-of-the-art Sierra Nevada Brewing Company Brewing Research Laboratory, where it looks like they could be just as easily researching the next medical advancement.

"I first crossed paths with the Davis program in the late '70s. I was a home brewer and aspiring to be a commercial brewer, and Michael Lewis and

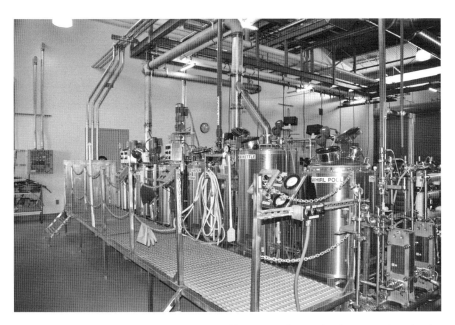

Current UC Davis Brewery. It was constructed in 2001 and moved to its current location in 2010. *Author's collection.*

some of his grad students were very helpful. I used a lot of the resources at the UC Davis brewing library; I spent quite a bit of time studying and researching brewing science at the UC Davis library," Sierra Nevada owner Ken Grossman explains.

Grossman and his wife, Katie Gonser, also donated another $2 million to give the university its first endowed brewer. "My family and I have supported the brewing program at UC Davis for nearly two decades," said Grossman when he announced this endowment. "The ideals that Charlie Bamforth and the rest of the staff instill in the students are the very same principles that have guided our success in craft brewing for the past thirty-six years."

"We think it's vital to support that institution that's doing great research and training the next generation of brewers," says Grossman.

As the program has seen these improvements in equipment and resources, the brewing courses have continued to grow in popularity. "This included starting a new class, a general education class," says Dr. Bamforth. "Now between 1,200 and 1,400 students a year take this class: Introduction to Beer and Brewing. It became the most popular class on campus." It's so popular that Dr. Bamforth—in a pioneering venture at UC Davis—is teaching it online as an offering to students at other campuses in the UC

Inside the Sierra Nevada Brewing Company Brewing Research Laboratory at UC Davis. *Author's collection.*

system. "There's no shortage of students who want to take the class. They're climbing over one another."

And it's not just the general class that is showing growth. He says his upper-division lecture course, which he describes as involving "hardcore science," had about twenty students when he took over the program. Now it's about eighty. Some of that growth may be due to the overall popularity of craft beer, but it probably has just as much to do with the passion Dr. Bamforth brings to the job. "I'm a great champion and great advocate for beer," he says with a hint of a smile on his face. "[Students] come to Davis thinking they want to be a medic or something, and I turn them into a brewer."

"You've got to remember that when people think about UC Davis, for the longest time they thought wine. And of course it's very important, and there's a whole department given over to it, viticulture and enology," says Dr. Bamforth. "But I'm holding up the end for beer. I like to think I'm here to keep those wine guys honest because the reality is…beer is much more complicated."

UC Davis is also one of the world's leaders in beer research and development. In fact, Dr. Bamforth says per capita, the university publishes more on beer research than anyone else in the world.

"We do a lot of fundamental research that is published extensively," he says. "Also, we interact with the industry a lot. Our brewery is used to help people develop new products and new ideas. We help people make beers and new brands of beer. We help those who want to supply different processing materials to the industry, maybe somebody who wants to sell a new cleaning agent or a new filtration device or something like that. We have a very intimate relationship with the industry."

While research and development are important and a good way to keep money coming into the program, Dr. Bamforth is sure to make it clear what his program is really about. "Our principal product is people. What we're particularly keen to do is to deliver brewers and other people into the brewing industry and related industries," Dr. Bamforth explains. "I think people want to recruit a brewer that has the UC Davis imprint on them."

Dr. Bamforth will retire from his role as distinguished professor on campus in December 2018. He has clear visions of how he would like to see the program continue to evolve:

> *It'd be great to have a couple other endowed professors and an ever bigger brewing program that could go farther and farther and reach out still more. My dreams—and I can assure you I've discussed these with my advisory*

group, including Doug Muhleman and Ken Grossman—is that it could be more to more people with the necessary resources. At the moment, it's not so much the equipment we're limited on, it's the people. So I'd like to think that, going forward, we'd have more than one core brewing professor. There would be a whole team of people that could do even more.

Still, Dr. Bamforth will leave an indelible mark on the nation's oldest university-level brewing program. He says:

Compared to where we were when I arrived here, which was a decrepit little brewery and nothing much else, we have come a vast distance. We now have an amazing facility, laboratory and brewery. Through the generosity of Ken Grossman and his wife, Katie Gonser, we have solid funding for the full-time brewer's position, held by the excellent Joe Williams. Most recently, Carlos Alvarez, founder of the Gambrinus company, donated $1 million to allow us to greatly expand the fermentation capabilities and further enhance the brewery and research laboratory. I feel that I will be handing over to my successor a package that is vastly better than what I inherited.

Brewing Beyond Campus

As mentioned previously, in the late 1980s, craft beer began to take off, and at the UC Davis campus, Dr. Lewis saw a new need for another type of brewing education at UC Davis: an education that would target those people who were going to be craft brewers but had neither the time nor the energy to complete a four-year degree in brewing

"So what was needed was some kind of a short but thorough education, an intense education in brewing science and technology and engineering," Dr. Lewis explains. "The only way to do that was with university extension."

That's when he began the Master Brewers Program. The eighteen-week course runs January through June and is taught by Dr. Lewis, Dr. Bamforth and others in a classroom at the Sudwerk Brewery. The course covers both brewing science and brewery engineering. That means you'll learn everything from malting and fermentation to fluid flow and solid-liquid separation.

"I think people who are going to have a career in the craft industry and certainly in the industry at large need to be able to explain why they know what they know. So it's good to become a leader or a head brewer or a

Students learning from UC Davis brewer Joe Williams during a short course offered during August 2017. *Author's collection.*

brewery owner or a technical director or something [where] you really need the more formal instruction," Dr. Lewis explains.

While more open to the general public, these classes are directed at people who want to join the brewing industry as professionals. You don't have to have a college degree, but you are asked at least to be proficient in a number of scientific areas.

"We want them to have a very good chance of passing the exams of the Institute of Brewing and Distilling and a very good chance of learning what we are teaching. So we don't care where you have been previously; once you decide you want to be a brewer, we ask them to take chemistry, biology, microbiology, physics classes at their local community college before they come to Davis. So that's the prerequisite that we have, that they have the exposure to those topics before they come."

Many of these same requirements must also be met to take part in the Professional Brewers Certificate Program. These courses aren't cheap, costing several thousand dollars each, but that hasn't slowed interest in the extension program.

UC Davis also offers another level of brewing education in the form of one-week short courses. These courses include Dr. Bamforth's Introduction

to Practical Brewing (taught four times each year), as well as classes aimed at the home brewer like Brewing Basics: Going Beyond the Kit.

"Historically, the Master Brewers Program has been very much theoretical. A lot of classroom work," says Dr. Bamforth. "I feel very strongly that brewing is a practical matter. That's why we're so blessed to have the facilities we do now, because I can describe something to someone in a classroom, but it's only if you do it in a brewery or laboratory that you really get to understand it."

These courses are very hands-on. Students get the opportunity to brew at the beginning of the week and at the end. They also attract a wide array of people who have various interests in brewing science.

"It's a lot of home brewers and a lot of would-be brewery owners, building their own product," Dr. Bamforth says. "There are some people from bigger brewing companies, particularly from nontechnical areas—they may be in sales or marketing, they may be procurement. They want to understand what the business is about."

Jake Wackerman is a good example of one of those students. He took the practical brewing course in late August 2017. He owns the 1850 Restaurant and Brewery in Mariposa. He says he was taught to make beer by a local brewer in his town but was striving to make it better.

"Trying to make cleaner beer, know scientifically what's going on I guess is what I wanted to get out of it," Wackerman says. "I brought up samples for Charlie and Joe [Williams], and the whole class tried them, and it was very apparent that I had an oxygen problem going on, which was causing some staleness in the beer. Even though it was two- or three-week-old beer, it was still oxidizing in the kegs. I got to learn the technique on the first day of brewing how to pretty much keep oxygen out of the environment."

"There are two ways, in my opinion, to become a brewer," explains Dr. Bamforth. "You do the theory, then you go off and get a job as a brewer. The other way that we have, particularly with some of the extension students, is that they get a job in a brewery, they're schlepping liquids around or shoveling grains, doing all that and they are learning it on the go, they need to do this, they need to do that. Then they come to us, and we tell them this is what's happening and they go 'ah'; the lightbulb goes on, and then they get it."

Just days after the one-week course was complete, Wackerman was already applying what he learned: "I couldn't wait to get back to the brewery and just fix the things I knew I could fix right away."

Dr. Bamforth figures that between the campus courses, the Master Brewers Program and the short courses, UC Davis averages about one hundred people heading into new brewery jobs each year. Some of those students will open their own breweries, and others will brew for some of the nation's and world's largest beer makers, including Anheuser-Busch Inbev, Molson Coors and Sierra Nevada.

"Over the years, we've had very strong connections with UC Davis, both by hiring many of their graduate students from their brewing program as well as their other shorter brewing programs," Ken Grossman says. "They've been one of the premier teaching institutions in brewing science."

"Pretty much anywhere you look, you'll find a Davis person. There are certainly people across the planet. UC Davis is very well known globally," Dr. Bamforth beams. "In terms of numbers of people in the team on campus, we're small, but in terms of global reach, in terms of presence and exposure and output, I think we equal anybody."

CHAPTER 11
THE POLITICS OF BEER

Beer and politics. Politics and beer. The two go hand-in-hand. Prohibition, of course, is the ultimate example of alcohol and politics colliding. But there have been plenty of other examples:

- Sacramento pioneering brewer Frank Ruhstaller was once nominated for sheriff. He ultimately turned down the position.
- As mentioned earlier, Governor Brown signed law in 1982 making brewpubs legal.
- In Colorado, Wynkoop Brewing Company co-founder John Hickenlooper successfully ran for governor, not once, but twice.
- In 2009, President Obama held a "beer summit" to tackle a complicated race issue.
- Going way back, founding father Samuel Adams was a partner in his family's malthouse. And of course, now there's a beer named after him.

The point is, brewing and politics are basically the peanut butter and jelly of life. And being that Sacramento is the capital of the most populous state in the Union, the two often intersect. So it should come as no surprise that the region was ground zero for the formation of the Northern California Brewers Guild.

"We started the Northern California Brewers Guild, the six breweries in town," says former Rubicon owner Glynn Phillips. "It would go from

Members of the Sacramento Area Brewers Guild gathering at New Glory Brewing Company for the group's monthly meeting. *Author's collection.*

Fresno all the way to the Northern California border." Phillips says because so many breweries opened in this region, they started an additional chapter called the Sacramento Area Brewers Guild. "The needs of Sacramento are very different than the needs of Sonoma County or Marin County."

While the guild does not currently include every brewery in the region, it continues to grow and evolve.

"As a guild, our number one goal is to help, not just to promote craft beer and craft brewing in Sacramento, but to actually help the bottom line of every single one of these breweries as businesses," says current guild president and Sactown Union co-founder Quinn Gardner. "Because one of the best things we can do to help craft beer grow and thrive in Sacramento is to help all of these guys be better businesses."

The guild has some big goals. Probably the biggest is trying to make the California Commercial Beer competition at the state fair the second-largest craft beer competition, behind only Denver's Great American Beer Festival.

Every region in the state has its own guild these days, but when issues facing breweries go beyond their political reach, they often turn to another group: the California Craft Brewers Association.

Beer Pairing: For this one, I'm not going to recommend a beer as much as a beer-related event. New Helvetia periodically hosts what it calls "Wonk Wednesday." They take a political topic and, over beer, have some friendly debate. If you can't make it there, then pick up one of New Helvetia's Indomitable City Double IPAs and keep reading.

CALIFORNIA CRAFT BREWERS ASSOCIATION

While the Sacramento region may not have the brewing prestige of regions like San Diego and the Bay Area, it does have something they do not: the state capitol. Sacramento is a government town where decisions that affect the entire state are made, which is why it makes sense that it's also home to the California Craft Brewers Association (CCBA).

The CCBA is the oldest state-based trade association in the country. It was founded in 1989 by craft beer pioneers like Fritz Maytag (then owner of Anchor Steam) and Sierra Nevada's Ken Grossman.

"Our mission statement is to empower the craft-brewing industry in California through education and protection," says CCBA executive director Tom McCormick. Part of the protection is making the voice of the brewer heard at the state capitol. "Government affairs, still today, is a big, big part of what we do."

"It is the place where there are a lot of decision makers and people we want to continue to educate about our industry and help support the growth of our industry," says Grossman.

McCormick works out of the CCBA office located just blocks from the state capitol. The CCBA keeps tabs on all things beer related making their way through the legislature or changes within Alcohol Beverage Control. McCormick then conveys that message to members of the association, including the Sacramento Area Brewers Guild.

"The CCBA works closely with regional guilds throughout the state, including the Sacramento Area Brewers Guild, providing a variety of resources, information and services to benefit the guilds and its members. This includes everything from legislative updates at member meetings to local ABC regulation seminars to one-on-one consultation for staff or boards of directors on addressing local issues," says McCormick.

"They have a lot of resources they can offer breweries, whether it's training in QuickBooks or ABC laws or best practices in your tasting room or what

have you," says Gardner. "Their role is continuing to evolve. The primary thing they do for all of us is the legislative work."

Gardner says a major thing the CCBA is doing is working to make the laws that govern breweries fairer. That includes excise tax brewers pay for each barrel of beer they produce. "We have to pay it for the pleasure of brewing beer in California and the United States. Part of what the CCBA is working on is making that paper trail a little more clear—where is that money going, who's spending it, what is it being spent on and is it things we all agree on."

During a meeting with the guild in early July, McCormick talked to guild members about changes to laws involving the use of fruit in their recipes. They also discussed the use of a logo that would identify true craft beer from the "craft breweries" that are now owned by the big companies and giving updates on options for group healthcare plans.

"The number one thing that I get out of it is…answers," says Fountainhead Brewing Company co-founder Daniel Moffatt. "If you're not sure about something, it's the first place you can go," he says. "It's just so easy. And being that we're in Sacramento, you can just stop in."

CALIFORNIA CRAFT BEER SUMMIT

Another big part of what the CCBA does and a way that it certainly gets noticed is by hosting the California Craft Beer Summit and Brewfest. The three-day affair brings brewers and vendors from around the state inside the Sacramento Convention Center.

"It's no coincidence that we hold it at the Sacramento Convention Center, which is literally across the street from the state capitol," McCormick says. "We really wanted to kind of show off and profile our industry to the policymakers in the state capitol, and it works. Six thousand people come into town, two-hundred-plus breweries."

"It's been a very positive thing for California in general from a revenue source and tax source and a homegrown industry. I think it's great that we're having it in Sacramento," says Grossman.

Inside the convention center, you will find vendors ranging from graphic designers for labels, T-shirts, bottles and tap handles to canning line vendors to lawyers who specialize in beverage control law.

"You get to cut through the sales pitch and actually get to talk about what we really need to talk about and what we're interested in," says Gardner.

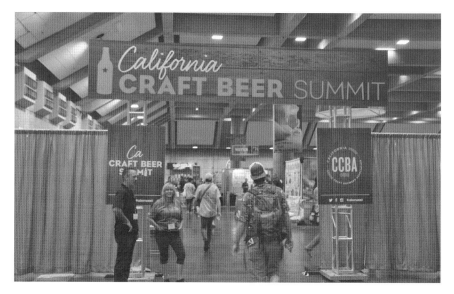

The entrance to the Sacramento Convention Center for the California Craft Beer Summit. *Author's collection.*

Inside the California Craft Beer Summit at the Sacramento Convention Center. *Author's collection.*

Moffatt agrees: "We leave there with a bag full of business cards and catalogues, and it's all relative. Everything that breweries actually use is there. It doesn't feel like a sales pitch; it's relative information, so it's very helpful."

Beyond the vendors, there are cooking demonstrations and food pairings (my personal favorite at the 2017 summit was the Brown Butter Cookie

A pause in the Ping-Pong action at the California Craft Beer Summit. *Author's collection.*

Company cookies and Firestone Walker's Velvet Merlin Milk Stout on nitro). For some reason, there was a Ping-Pong table (no, they weren't playing beer pong) and information on how to become a cicerone (think wine sommelier only for beer).

And of course…beer. Every region of the state is represented by its brewers' guild.

"Here you have an opportunity to drink beers in Sacramento that you can't get here from some kickass breweries in SoCal and the Central Valley and the coast and even up north and Tahoe," says Gardner. "It's a cool opportunity."

"It's not exposure in the sense in, 'Oh hey, try my beer,'" says Moffatt. "It's more that you get to meet people who you probably would not have the opportunity to meet otherwise, both your peers and people who we consider our heroes."

And that's probably the biggest draw for folks in the industry during those first two days of the summit: the guest speakers. The lineup is a veritable who's who in the craft beer industry in California and beyond. The summit features Tap Talks (think TED Talks but with beer) with notable guests like Grossman, Dr. Michael Lewis and Charlie Papazian, founder of the Brewers Association and considered the founder of the modern home brewing movement.

Tap Talk at the California Craft Beer Summit, featuring Sierra Nevada founder Ken Grossman (*left*) and CCBA executive director Tom McCormick. *Author's collection.*

"I remember saying in the very early '80s, 'A home brewer in every neighborhood; a brewery in every town.' That was my vision," Papazian told the crowd during his talk, which drew a huge crowd. A Q&A session with Grossman just a half hour later brought an even larger crowd, showing the kind of draw these talks have.

"When the California Craft Brewers Association picked Sacramento to be the city for the beer summit, it focused all this attention," says former *Bee* writer Blair Robertson. "We became the center for California beer in a way. Every famous brewer—Ken Grossman, Vinny [Cilurzo] from Russian River, David Walker—everybody was in Sacramento. It made us look really cool and made us look essential."

"I met Charlie Papazian and Ken Grossman," Moffatt says. "People who have been pioneers in this whole industry, and they're there and they're accessible and they're talking to you. For those of us in the industry, those are like our celebrities, so that's pretty cool."

The third day of the summit features the largest gathering of craft breweries on the West Coast. The 2017 Summit Beer Festival featured more than 160 of California's craft brewers, from the giants like Firestone Walker and Sierra Nevada to newbies like Rancho Cordova's Fort Rock Brewing Company. This event is a beer lover's dream.

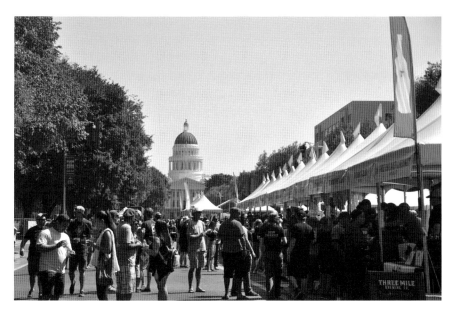

The California Craft Beer Summit Brewfest, where 150 breweries line Sacramento's Capitol Mall. *Melissa Chechourka Collection.*

"The third annual California Craft Beer Summit was the most successful yet on all levels," says McCormick. "The 2017 summit featured an expanded trade show, more chef demos and food options, a wide diversity of educational seminars and the largest attendance to date."

"I think the summit really elevated our reputation or solidified it," adds Robertson.

McCormick says not only does the summit help put Sacramento on the map, but it also keeps craft beer on the minds of lawmakers. "The primary reasons are to profile our industry to the legislature, also as a fundraiser, and then as an education and promotional opportunity as well. We're probably going to keep it in Sacramento for that reason."

CHAPTER 12
THE HOP COMEBACK

Hop growing is incredibly labor intensive, particularly harvesting. Hop growers basically spend April to late August tending to the vines, but there's plenty of work to be done even before that. Hops are a creeping vine, which means they need something to grow up. There are several types of systems, but the most basic can be found at the Ruhstaller hop yard, where a cable is strung between two rows of plants. A string is then run from the plant on each side up to that cable essentially creating a V. The grower then picks a vine to "train" to grow up each string. Come harvest time, those strings can just be cut down.

Hops grow incredibly fast. They can grow as much as a foot a day, reaching heights of thirty to forty feet. When they stop growing up, they start growing out with lateral shoots that will eventually hold the hop cones. Once those cones get to a certain level of dryness, they are ready to be picked.

You basically need three things to grow hops: sun, a lot of water and fertile soil. As we've discussed, those early hop farmers found plenty of all of these things in the Sacramento region. And as it turns out, those things still exist here, which is part of the reason we're starting to see a hops rebirth.

Beer Pairing: One of the benefits of growing hops so close to breweries is the ability to make "wet hop beers." Instead of using hops that have been cured, the hops go directly from the vine to the kettle. This makes for some dynamic and sometimes unusual flavors. Since the next section is all about hop growing, I suggest Ruhstaller's Hop Sack. Unfortunately, these beers are usually only offered in the fall during harvest.

THE NEW HOP PIONEER?

The Sacramento region at one time led the world in hop growing, but by the time JE Paino planted the first hops for his Ruhstaller farm, it was an all-but-forgotten industry in the area.

"When we started in 2012, those were the first hops planted in the Sacramento area in probably two generations. It was the first harvest in fifteen or twenty years," says Paino. "It started with Darrel Corti and a challenge."

That challenge came during a meeting in late 2011, after Corti Brothers began selling Ruhstaller beer.

"[He said], 'You guys are the guys with Ruhstaller on the bottle?' I said, 'Uh huh.' He said, 'You guys are the ones with Sacramento on your bottle?' I said, 'Uh huh.'" Paino recalls. "I was sort of expecting a pat on the back. And he said, 'You guys don't deserve those two words unless you grow hops.'"

Here was the beer company that prided itself on using locally sourced ingredients the way the pioneer brewers had, being called out for not truly being farm-to-fork.

"When Darrel challenged us, we knew that basically we hadn't done enough; we needed to try to do more." And that's when Paino became a hop farmer. The problem was nobody was really growing local hops anymore.

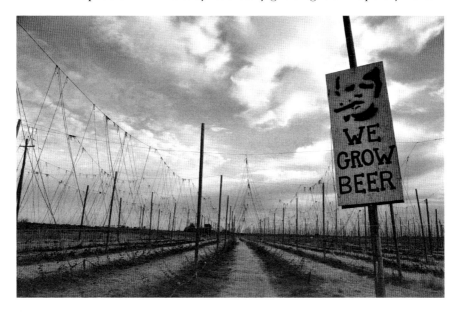

Ruhstaller hop yard in Dixon, California, in July 2017. *Author's collection.*

The same location three months later, showing how quickly hops grow. *Author's collection.*

"It's a bit of a loss. The memory of it is, unfortunately, somewhat lost," says Paino.

The last large-scale hop-growing operation in the region was owned and operated in Sloughhouse by the late George Signorotti, but it shut down in 1985. After that, the Signorottis continued to grow hops exclusively for the Anchor Brewing Company until 2004.

With Corti's help, Paino was able to connect with George's widow, Virginia. "She tried ten times 'til noon to talk me out of growing hops, about how difficult it was and how time consuming, etc., etc.," says Paino. But eventually with Virginia's help, Paino was introduced to David Utterback, who, despite not necessarily wanting to grow hops for Paino, would prove vital to the whole operation. Utterback was a sod grower who had purchased the Signorotti farmland. In doing so, he also kept some of the original hop roots, which he supplied to Paino.

Having the roots was a good start, but Paino still needed help actually growing the plants. At an event for the Center for Land-Based Learning, Paino addressed a group of young farmers to see if they'd be interested in growing hops. He not only guaranteed to buy whatever they grew, he also offered to front them money to get started.

"One guy came back to me a week later with a plan. That was a guy named Sean McNamara." McNamara is the son of Craig McNamara, who also happens to be one of the founders of the Center for Land-Based Learning and is also the grandson of Robert McNamara, the former president of Ford Motor Company.

McNamara did as much research as he could learning from books, things like how to set up the trellis system and so on, but what they lacked again was institutional knowledge. That's where Utterback came up big again, introducing Paino to a man named Ephraim, who had worked for the Signorottis.

"Ephraim had come here as a teenager and worked with George for fifty, sixty years. Ephraim was the guy we really learned from. We would bring him out on like a monthly basis, and he would tell us what to do and what not to do," Paino recalls.

Ephraim supplied the know-how the Ruhstaller team was missing.

"He didn't necessarily know why—it wasn't like talking to a scientist who would explain the biology of what we were doing—but he knew all the tricks," says Paino. "We learned so much from him; he didn't know how much he knew, but from his experience, he knew more than anybody in Sacramento, maybe in California."

Through trial and error and with a bit of luck, Paino and his team completed that first harvest and used their new hops to create Ruhstaller's Hopsack, a wet hop beer.

The partnership with McNamara was short-lived. But the infatuation with growing hops has only, well, grown. Paino moved the farm to Dixon, right along Interstate 80, where they could expand to roughly seven and a half acres. He says the location is beneficial in several ways, most notably the wind because it helps keep mites and mildew at bay.

During hop season, the Ruhstaller co-founder is getting his hands dirty. He gets up early and works late, just like any other farmer. In fact, when you see Paino in the field tending his farm, it looks like it's exactly where he should be. Early in the process, Paino relied on volunteers to help maintain, train and harvest the hops. These days, he has to rely on himself and a handful of paid workers.

Ruhstaller has been growing hops for five years. Some years have been better than others, and Paino will be the first to tell you they are still learning. "We still make mistakes every year," he admits. "But we're making fewer of the same mistakes, which is good. We're getting better."

Not all of Ruhstaller's hops come from the Dixon farm. The brewery also relies on hops from farms in Sloughhouse and Lake County, which is home to the state's largest hop ranch. In 2017, Ruhstaller issued a four-pack of beers called Does It Matter IPA. Each beer in the pack was brewed with hops from a different region (Dixon, Sloughhouse, Lake County and what are called orphan hops). The goal was to see if people could tell the difference in taste, and if so, perhaps it would reinforce the pioneering farm-to-pint philosophy Ruhstaller has been built on since the beginning.

"If the consumer and the beer lover can appreciate the flavor of Sacramento, what the hops can taste like here, and then maybe other brewers use some of those hops, then you can start calling it something. I still think we're kind of pioneers."

Pioneers perhaps, but certainly no longer alone on Sacramento's burgeoning hop-growing scene.

THE UNLIKELY FARMER

Earlier, we introduced Ro Nayyar, the owner of RoCo Spirits and Wine and part owner of United Hop Farm.

"In Sacramento, the consumers want farm-to-fork. This is farm-to-pint," he explains.

Nayyar says the hop farming grew out of his relationships with the local brewers and distributors. He explains that it was Julien Lux from New Glory who initially suggested the hop idea. "I like doing different things, I like expanding out there and I like challenging myself. He [Julien] knew that we did some farming in Yuba City, and he goes, 'Hey Ro, you know what would be cool? If you grew hops for me.' And I was like, 'OK.'"

Nayyar and a friend did indeed have a farm in Yuba City. They were using it to grow peaches, but he says after doing some research, he was intrigued by the hop-growing idea. The problem was, like Paino and Ruhstaller, he didn't know anything about growing hops.

"We were like, 'We need to get some real experience. What we need to do is actually go and meet with the bigger farmers.' So we went to Oregon and went on a hops exploration." Nayyar says one of the growers they reached out to was Goschie Farms. Gayle Goschie's family has been hop farming in Oregon's Willamette Valley for more than a century. "She's like, 'Yes, I'd

love to meet you guys.' She spent three hours with us teaching us about the hops processing. You go there, and she's teaching us about how it's grown to how it's picked, sharing her best practices, how we can do this. Even until now, we have her cellphone number; anytime we have any questions, we pick up a phone, we give her a call and she's more than happy to answer any of these questions." The exploration would also take them to giant hop farms in Yakima, Washington.

With hop farming knowledge in hand, Nayyar and his team planted a small quarter-acre hop yard. "That was such a success that over the last four years, we've grown the hops yard a lot more," he says. His Yuba City farm is now fifteen acres, plus he manages another five acres in Hood selling hops to dozens of the Sacramento-area brewers, including New Glory, Jackrabbit and Knee Deep.

Believe it or not, he says one of the varieties of hops they are growing actually came from a hop plant they found growing in the wild in West Sacramento. "We've propagated hops off of there. We picked up the rhizomes and brought them into the commercial field, and they do fantastic in the commercial fields. They were just going wild." Wild hops are common throughout the area.

The brewers are not only buying the hops, but they also often pitch in when it comes time to harvest. Nayyar says, "Brewers wake up at four in the morning, go out there and help us pick hops, and then we drive down by nine o'clock and they have the mash going, and we're dumping all the hops into the mash. It doesn't get any fresher than that."

"In August, September, everybody will be doing these fresh-hop beers, and then by October, November, these fresh-hop beers are coming out, and it's just amazing when you sit back and drink that pint that, hey, you are the person that grew these hops."

Nayyar admits that he and his partners still have a lot to learn about hop growing. It's why every year they return to Oregon and Washington for their hop explorations. He says they try to spend at least a week each year learning from these hop-growing giants.

"Over the years, I learned so much about farming—how hard it is. You have to be out there, and it's a whole other respect for that industry, is that what goes into it before the beer is even made," Nayyar says. "You go out on the farm and it's all quiet, and you're out in the nature and just growing something with your own hands; it's an amazing feeling."

Nayyar is the epitome of the entrepreneurial spirit in the craft beer industry even though he doesn't make beer. He's a bottle shop owner, a

taproom operator and a hop farmer, but he says it's pretty clear which of those jobs sparks the most conversation: "The hop farming is definitely the sexy part of it."

THE FUTURE OF HOPS

At one time, there were thousands of acres of hops in California. Now, that number is fewer than two hundred. So can hops make a comeback here? Well, the odds are certainly stacked against the Golden State.

"Two things right now [are] our biggest challenges. Number one is the market: the craft brewing market is leery of California-grown hops because it hasn't been done well by particular growers," says agriculturalist and ag historian Rory Crowley. "Secondly, we just don't have the infrastructure right now."

Ro Nayyar agrees: "We don't have big enough harvesters, we don't have big enough facilities to provide hops to the breweries yearlong. We can give them hops for the fresh hops season, and after that, they don't hear from me for a whole year."

Paino says consistency in the quality of the hops is a challenge. While growers in Oregon and Washington have thousands of acres to pull their hops from, the growers in the Sacramento region are farming on just a few dozen acres at most.

"You can convince a brewer that California-grown hops, Sacramento-grown hops are of a different character, and no one doubts that," says Paino. "The next thing you can probably get most of them to say, 'Yeah, that's a better hop. It tastes better, it has better quality.' But they will all start to balk when you can't guarantee consistency."

But perhaps the biggest challenge facing local growers is that they can't legally grow the most popular hop varieties.

"Oregon and Washington, they produce 80 percent of all the hops consumed all over the whole world. They have massive farms," says Nayyar. "They have the proprietary hops, like nowadays the hazy beer trend, you have the galaxies, the Idaho 7s, the Mosaics, the Simcoes, those are proprietary hops that we can't grow." To combat that, Nayyar says he's trying to figure out how to partner with UC Davis to breed a new variety of hop.

Paino says the two to three inquiries he gets a month at his hop yard prove that the interest in hop growing exists. "If it's going to happen, it's going

Hops that have been harvested and will be sent to the picker to separate the hops from the bine. *Author's collection.*

to happen here. There are a lot of farmers and a lot of farmland. I think people kind of get it. The younger farmers are kind of into it. They get it."

Crowley warns that California hop growers need to avoid being their own worst enemies. "Hop growing, in and of itself, is a highly unique skill that requires a lot of specificity," he explains. "[Some growers are] pumping them out, they're not feeding them properly, they're not processing them properly and then they're peddling them at a price that is unsubstantiated as well."

He says these modern California hop farmers have a responsibility to get it right. "[These growers] have the ability to decimate our initial push of pioneering back into the hop-growing world. Those are very strong words, and I'm going to say it."

Paino and Nayyar's United Hop Growers group members are part of the California Hop Growers Association (CHGA). The goal of the organization is to help rebuild the industry in California.

"I think the goal is two things: number one, to help create a market for hops but also to help more farmers grow hops, and then not only farming, which is half of it, but the processing of it, the picking it, the drying it, the bailing it and the pelletizing it."

The CHGA has been part of the California Craft Beer Summit the last few years in an attempt to get the idea of local hops in front of the local brewers. But Paino admits that until they are making better beer with the local hops, it won't make a difference. "We have to make beer where people are like, 'Wow, that can't be made anywhere else in the world.' We haven't done that yet, so I don't expect too many people to gaga over Sacramento-grown beer. Someone has to show them that it's possible."

Ruhstaller grows hops, but Paino says the company did not set out to revive Sacramento's hop industry. But he does have a goal for California as a whole. It's not to grow more hops than Oregon or Washington but Michigan. "Michigan has 350 acres of hops. If we can't grow more hops than Michigan…"

The Sacramento region was and will always be a place where hops can thrive. So the question is not whether they can be grown but whether there's enough interest in what can be grown here to sustain the industry.

Nayyar believes there is: "Every person that we've reached out to in the brewing industry, you call them up and you tell them you're growing hops locally, no matter who it is these guys are like, 'Yes, we're going to do something with locally grown hops because this is what California is all about.'"

CONTINUING EDUCATION

I f you are looking to become a brewer or brewery owner, the best education in the world is just down the street at UC Davis. If you're looking to just learn a little bit about making beer or growing hops, those options exist here as well.

YOLO Brewing Company offers personal brewing. This is truly BIY: brew it yourself. If you can dream it, they will help you make it. What you might not know is just how long this program has been around and how rare it is to have this opportunity.

Or maybe you're thinking about growing your own hops. Where do you start? You might want to check out Ruhstaller's Hop School. It's a crash course of training, trimming and growing hops.

These are both learn-by-doing experiences that will cost you a lot less than a four-year degree.

Beer Pairing: This is an easy one. Get some friends together and set a date to do some personal brewing at YOLO Brew, and in a few weeks, you'll have your self-made beer to enjoy. No beer will ever be more satisfying than the one you made yourself.

BIY: BREW IT YOURSELF

When is home brewing not home brewing? When you're doing it away from home. It might sound like a confusing riddle, but it's actually part of the business model for West Sacramento's YOLO Brewing Company. The brewery is one of the few in the entire country that lets visitors brew and bottle their own beer.

"It's kind of a way to get people who are interested in home brewing [but] don't necessarily want to invest in the equipment yet until they see if they actually like it," says YOLO Brewing CEO Rob McGormley

While YOLO Brewing is only a few years old, the personal brewing aspect of the business actually dates back nearly twenty years with the brewery's founder and former general manager, Michael Costello.

UC Davis–educated Costello opened Brew It Up in Davis in the mid-'90s. It was a small shop that offered beer lovers the opportunity to brew their own beer with professional help. The process eliminated the complexities of home brewing and the risks of making something that was undrinkable. In an interview with Costello from 2016, he admits he underestimated just how popular it would become: "I went into it thinking it is one kettle, one batch, one person. 'Hey, we have six kettles we're going to have six people here.' But no, it was six people per batch. So it was often just a big party."

That popularity prompted Costello to expand and move Brew It Up into downtown Sacramento and reopen as a brewpub. The restaurant was never known for great food or great beer, but it can be credited with helping push Sacramento's craft beer scene to where it is today. That's because it's where several of the area's current brewers and brewery owners got their start.

"My dad and I went to Brew It Up way back in the day," says Track 7's Geoff Scott. "We made a batch of beer there, and [it] kind of turned me on to making beer at home and kind of finding creative ways to change beers and to make your own stamp on a beer."

"When I really started enjoying [home brewing], I would go to Brew It Up downtown," says New Helvetia owner David Gall. "I'd call them at like 10:30 on a Tuesday morning, and I'd say, 'Hey, when's the earliest I can brew a batch?' Whoever the staff was would say, 'OK, well 11, when we open, we have an opening.' So I'd just go and brew something."

The brewpub lasted eight years before Costello says the combination of poor location, a struggling economy and mounting debt forced Brew It Up to close.

A customer stirring the kettles at YOLO Brewing Company during a personal brewing session. *Author's collection.*

The kettles used at YOLO Brewing for both making beer for the brewery and for personal brewing sessions. These are the same kettles used at the original Brew It Up. *Author's collection.*

"When Brew It Up failed, I had a lot of people approach me quickly and say, 'I want to be involved the next time around' and I'm like, 'Do you see what's going on here? This isn't success.'" Costello says he was convinced that Brew It Up's problems were things that could easily be corrected, so with the help of investors, he opened YOLO Brewing in 2014. While the food was gone, the personal brewing remained.

Costello describes the new brewery as "a place where people can come in touch with the brewing process, drink the beers on-site, drink the beers they can't get out in distribution."

His run at YOLO only lasted about two years. In early 2017, McGormley, who brewed at the original location in Davis and was an investor in YOLO Brew, took the lead. He has made several changes to the processes at YOLO, but the personal brewing has basically stayed the same.

You sign up for a personal brewing session online. The cost is around $300, which might sound like a lot, but you are guaranteed to bring home at least ten gallons of beer. Here's the other thing to keep in mind: you're getting professional help and a real lesson in brewing beer.

"One of our actual brewers, who do our commercial brewing, walks them through the entire process. So if they want to do their own recipe, the brewer will sit down with them to walk through recipe creation," says McGormley. "We take them through the process. They mill their own grain; we walk them [through] setting up the kettles, getting the hot water, everything boiling. And then each step of the process we take them through."

Not only are you using their actual brewers, but you also brew on the same equipment the brewery uses to make its beer.

McGormley says you can brew just about any kind of beer you want. Think of something crazy? They will try to help you come up with the recipe. Recently, a guest wanted to make a blueberry–maple pancake ale. "We had to decide, are you going to put actual maple syrup in there? Do you want to do maple syrup extract? Do you want to put actual blueberries in? Do you want to use blueberry extract? So we're really flexible on that kind of stuff."

Once your beer is made, YOLO Brew sets it up for yeast and then stores it until it's ready to bottle. Then you return a few weeks later to bottle your creation.

Like the original Brew It Up, the personal brewing is still a social event. McGormley says, "It's definitely about the experience. No one comes in here and does it by themselves like you would at home. Everyone comes in with a group of four or five people; they all take turns stirring, they take turns milling, they take turns putting the hops in."

More breweries are starting to look into the personal brewing model of doing business. McGormley says YOLO even received an offer from an East Coast brewery to buy its entire small-kettle system.

"It's not a standard business model at all for doing a brewery, but it was a niche we thought we could fill," he says. "There obviously a hole or a niche we can fill as far as educating people on how to brew your own beer and the science behind brewing."

Hop School

While learning to brew beer, you'll learn all about how hops are used. What you won't learn is how hops are grown. As we've examined in earlier chapters, hops were once a major industry in this region, but when it went away, so did much of the knowledge of hop farming. Ruhstaller's JE Paino is trying to change that with his "Hop School."

For this school there is no classroom and no books; just JE, some students and the Ruhstaller hop farm along I-80 in Dixon. "You can sit and talk about how to farm, but at the end of the day, you have to get out there and do it," Paino says.

Hop School was born out of necessity for Ruhstaller. In those early days of hop farming, Paino and crew relied on volunteers to help with the harvest. "We'd have a lot of volunteers to come out who'd want to learn; we'd have people come out on dates here and stuff like that. Families would come out here."

That changed after a Bay Area winery was hit with a huge fine for using unpaid volunteer workers. Paino decided they needed to find another way to get the help that wouldn't put Ruhstaller at any legal risk.

"We partnered with the Center for Land-Based Learning and got an accreditation," Paino says. Now, "students" pay thirty dollars to attend Hop School (that includes the lesson, lunch, a beer and a ten-dollar donation for the Center for Land-Based Learning). He says despite the change, interest has been strong, not only from people who want to just learn about hops but also from farmers who may be looking at getting into the hop-growing business.

"We start at seven and we go to, depending on how hot it is, until maybe ten or eleven o'clock," Paino says. "Typically, we talk a little bit at the beginning and tell you a little bit of what we're doing, why we're doing it

Above: JE Paino teaching class during Hop School offered at the Dixon hop farm. *Author's collection.*

Left: JE Paino and his team harvesting hops for a wet hop beer in September 2017. *Author's collection.*

here. How the hop grows, the stage of growth. Most of the time, we work. There's a lot of work to be done."

Paino says there is no lesson plan, and often the day is dictated by the students and their particular interests. "It's really just kind of to satisfy anyone's curiosity. It's about education and experience."

The one guarantee he can make is that you will work up a sweat, as the classes are only held during hop season, which starts in April and ends around the beginning of September.

"After a couple hours out here," he says, "the beer always tastes better."

CONCLUSION

SO WHAT NOW?

I started writing this book in April 2017; by the time I turned in my final draft in November of that same year, a handful of new breweries had opened, and more were on the way. The number of breweries in this region will soon reach seventy; this continues to fuel worries of oversaturation.

"When do we get there and what does oversaturation look like? I don't know," says CCBA executive director Tom McCormick. "I thought we would have reached it by now, but we're still seeing new breweries pop up."

Sacramento Area Brewers Guild president Quinn Gardner believes that based on the number of breweries in areas like San Diego, Sacramento could be home to another thirty or so breweries before we hit the saturation point. "If you run good business, you'll survive."

McCormick says what is more likely to change is the type of brewery we see open. "It's just getting really hard to open up a larger distributing brewery like, for example, Track 7 is doing. I think we're pretty close to saturation for that type of business model."

To that point, even if the Sacramento area is not oversaturated just yet, the field is certainly getting more crowded. And while that might mean more selection for beer lovers right now, there are only so many tap handles in the region and only so much shelf space at the store.

"There's still going to be quite a few openings; I don't really see that slowing down," says Fountainhead's Daniel Moffatt. "With each one that opens, it's going to be harder and harder to make your mark and stand out."

The popularity of craft beer in Sacramento is attracting breweries like Fieldwork from outside the region to set up taprooms. *Author's collection.*

The growing field of craft beer makers is creating what Auburn Alehouse's Brian Ford calls a soft market: "Everybody is in the same soft market right now, so hopefully people are paying attention to that and understanding that they are going to have to make good-quality beer in order to sell it."

Even those with a reputation for making good beer are starting to feel the effects of that crowded market.

In August 2017, it was reported that overall craft beer sales fell $143 million in the first half of 2017. Sierra Nevada reported retail store sales fell 7.5 percent, and for the first time in the company's history, the brewer's shipment volumes fell. Sierra Nevada wasn't alone; Sam Adams maker Boston Beer Company and Dogfish Head reported sales that were flat or down. Each owner blamed the crowded market for the slipping sales.[55]

"It's a challenging business, and there are some that are going to survive long term and some that are going to be challenged. If you're not able to… then there will be some casualties," says Sierra Nevada's Ken Grossman.

"We will eventually hit a ceiling where some of these new breweries, after being in business for five years, will say there's not enough money in it and I'm working sixteen hours a day and I don't know if there's enough money in it to continue," says Blair Robertson.

We've started to see that as well. A handful of breweries closed in 2017, including some that had been established for years, like the Rubicon and American River.

"Things are tough right now. When you're doing something of that size that the Rubicon was trying to do, you really have to make a lot of beer and sell a lot of beer to pay [for] the beers," says Auburn Alehouse founder Brian Ford.

Even in this soft market, craft beer sales in this country still topped $2.3 billion in the first half of 2017, so don't expect to see this wave of openings and closings end anytime soon.

Gardner also points to the success that Sacramento-area breweries are having, most notably at the 2017 Great American Beer Festival in Denver, where Mraz, Out of Bounds, Fort Rock, Crooked Lane and Auburn Alehouse all took home medals. Making that even more remarkable, Crooked Lane and Fort Rock are still new to the scene.

This brings me back to something Sacramento Beer Frontier's Aaron O'Callaghan said that stuck with me as I wrote this book. He basically said that we are living the new history of Sacramento's beer industry. Historian Ed Carroll, who spent years researching the original beer boom in this

Big Sexy Brewing Company is one of the many breweries that have opened in Sacramento over the last few years. *Graphics & Growlers.*

Fort Rock Brewing Company took home a silver medal at the 2017 Great American Beer Festival. *Author's collection.*

region, echoed that sentiment. "When my book came out, there really wasn't much going on here for beer, so people were really focused on where it all came from, and now it's like, 'Jeez, who can remember what opened last week?'" Carroll says. "This will be that time you hear about in thirty years, like, 'Oh, there's this brewing boom in Sacramento just like there was in the 1860s or 1890s.'"

This modern boom probably won't be stopped by something as drastic as prohibition, and who can predict how long it will last? After all, the Sacramento region may be closing in on seventy breweries, but that's still about half the number of craft breweries in San Diego.

So what now? Head to your favorite local brewery, order a beer, drink up and be sure to thank the beer maker. After all, they are making history, one beer at a time. Cheers!

NOTES

Chapter 1

1. Trevor Homer, *The Book of Origins* (London: Plume, 2007).
2. C.W. Bamforth, "A History of Brewing Science in the United States of America," UC Davis Dept. of Food Science and Technology, n.d.
3. *Sacramento Union*, "Brewing Big Industry in City of Sacramento," November 26, 1908.
4. Historynet.com, "Gold Rush Facts," World History Group. www.historynet.com/california-gold-rush.
5. *Sacramento Daily Union*, "A Glass of Lager," July 20, 1858.
6. Edward Carroll, "Brewing in Sacramento: 1849–1919," California State University, Sacramento Thesis Collection, 2008.
7. Colonel H.I. Seymour, manager of the Buffalo Brewing Company, *Sacramento Union*, November 26, 1908.
8. *Sacramento Daily Union*, "Brewers," January 1, 1880.
9. Carroll, "Brewing in Sacramento."
10. *Sacramento Daily Union*, "Frank Ruhstaller Answers Final Call," October 29, 1907.
11. *Sacramento Daily Union*, "Brewers," January 1, 1880.
12. *Sacramento Daily Union*, November 24, 1881.
13. Carroll, "Brewing in Sacramento."
14. *Sacramento Daily Union*, "Transfers of Real Estate," November 24, 1881.

15. I say "at least" here because I found an article that appears to indicate that two of his children died in a fire in 1881; however, I found no other references to this apparent tragedy.

16. *Sacramento Union*, "Gilt Edge Baseball Team of Years Ago Simon Pure Club," March 31, 1921.

17. *Sacramento Union*, "Ruhstaller Quits," September 12, 1906.

18. Anheuser-Busch, "For the Love of Lager: History of Anheuser-Busch," Anheuser-Busch.com/about/heritage.html, December 14, 2016.

19. Carroll, "Brewing in Sacramento."

20. *Sacramento Daily Union*, "The New Brewery," May 9, 1890.

21. *San Francisco Call*, "A Noble Brew," January 14, 1893.

22. *Daily Alta California*, "Buffalo Brewery," August 29, 1890.

23. *San Francisco Call*, "A Noble Brew," January 14, 1893.

24. Ibid.

25. *Sacramento Daily Union*, "New Brewing Company," May 25, 1892.

26. *Sacramento Union*, "Pioneers Passing Fast," October 12, 1913.

27. *Sacramento Union*, "Brewing Big Industry in City of Sacramento," November 26, 1908.

28. *Sacramento Bee*, "Buffalo Brewing Company Quits Operation Here," June 8, 1942.

29. *Sacramento Bee*, "Buffalo Brewing Company Plan Will Be Reopened," July 27, 1944.

30. *Sacramento Bee*, "McClatchy Newspapers Buys Buffalo Brewery Site for New Bee, KFBK Home," January 17, 1949.

Chapter 2

31. *Sacramento Union*, November 26, 1908.

32. *Healdsburg Tribune*, "More Hop Yards for Sacramento Growers," February 26, 1920.

33. *Pacific Rural Press*, "California Hop History—Who Is the Pioneer?" August 22, 1891.

34. Ibid.

35. *Pacific Rural Press*, "Hop Growing in California," June 11, 1881.

36. James J. Parsons, "Hops in Early California Agriculture," *Agricultural History* 14, no. 3 (July 1940).

37. Mark A. Tomlan, *Tinged with Gold: Hop Culture in the United States* (Athens: University of Georgia Press, 1992).

38. *Pacific Rural Press*, "The Hop-Picking Industry in California," July 14, 1894.
39. *Pacific Rural Press*, "Trellising for Hopyards," February 4, 1893.
40. *Press Democrat*, "Harvesting of the Hop Crop in Sonoma," September 29, 1912.
41. *Sacramento News & Review*, "Hops of Wrath," August 30, 2007.
42. *Sacramento Union*, "Four Die in Hop Pickers' Riot at Wheatland," August 4, 1913.
43. *Sacramento Union*, "Conditions in Hop Fields," August 17, 1913.
44. *Sacramento News & Review*, "Hops of Wrath," August 30, 2007.
45. *Sacramento Union*, "Sheriff Voss Is Shot Down at Head of Posse in Gun Duel with Mob," August 4, 1913.
46. *Sacramento Union*, "Being Tried for Murder," January 20, 1914.
47. 2017 August USDA-NASS Harvest Projection.

Chapter 3

48. *Sacramento Bee*, "River City Brewing Closes, Blame Debt Load," March 30, 1984.
49. *Sacramento Bee*, "The Hot Line," April 2, 1989.
50. *Modern Brewery Age*, "Fast Mover: The Deschutes Brewery Bucks the Trend with Continued Rapid Growth," September 13, 1999.
51. *Brewers Association*, "Brewers Association Releases Top 50 Breweries of 2016," March 15, 2017.

Chapter 5

52. Bill G. Wilson, *Gold & Schemes…and Unfulfilled Dreams*, Auburn, CA, 2002.
53. RateBeer, "RateBeer Best Awards for the Year 2016," January 30, 2017. www.ratebeer.com/forums/ratebeerians-of-the-year-awards-2016-the-winners_293109.htm.

Chapter 7

54. California Craft Brewers Association, "California Craft Beer 2012 Economic Impact."

Conclusion

55. Marketwatch.com, "Craft-Beer Glut Starting to Take Its Toll on Sales," August 23, 2017. www.marketwatch.com/story/craft-beer-glut-starting-to-take-its-toll-on-sales-2017-08-23#false.

INDEX

ABOUT THE AUTHOR

Justin Chechourka is the co-ringleader (along with his incredible superhero of a wife) of his very own circus that includes a baseball-obsessed seven-year-old and two wild and crazy twin two-year-olds. When he's not coaching or attending school functions, he is likely chauffeuring a child to their next birthday party. All of this helps explain why he has taken such an interest in craft beer. Not only does this enjoyable adult beverage showcase some of the best of what Sacramento has to offer, but the people behind these brews have great stories to tell.

Visit us at
www.historypress.net